LOOKING EAST

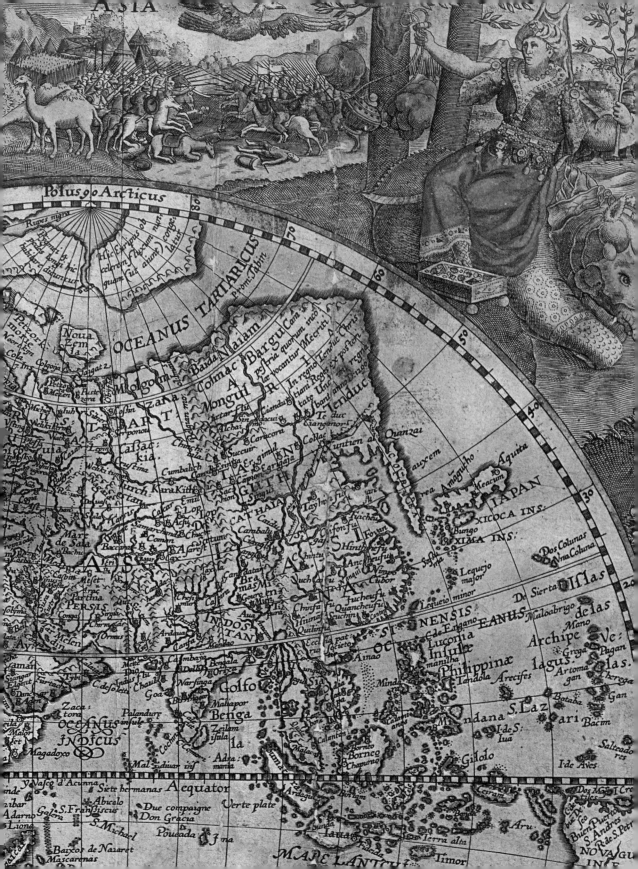

Looking East

RUBENS'S ENCOUNTER WITH ASIA

Edited by Stephanie Schrader

*With contributions by Burglind Jungmann,
Kim Young-Jae, and Christine Göttler*

THE J. PAUL GETTY MUSEUM
LOS ANGELES

This publication is published on the occasion of the exhibition *Looking East: Rubens's Encounter with Asia*, on view at the J. Paul Getty Museum at the Getty Center, Los Angeles, from March 5 to June 9, 2013.

© 2013 J. Paul Getty Trust

Published by the J. Paul Getty Museum, Los Angeles

Getty Publications
1200 Getty Center Drive, Suite 500
Los Angeles, California 90049-1682
www.getty.edu/publications

Dinah Berland, *Editor*
Jim Drobka, *Designer*
Elizabeth Kahn, *Production Coordinator*

Printed in China

Library of Congress Control Number: 2012953496
ISBN: 978-1-60606-131-2

Front cover: Peter Paul Rubens (Flemish, 1577–1640), *Man in Korean Costume*, ca. 1617 (detail, fig. 1).
Back cover: Peter Paul Rubens, *Man in Korean Costume*, ca. 1617 (fig. 1).
Frontispiece: Petrius Plancius (Dutch, 1552–1622), *Orbis Terrarum Typus De Integro Multis in Locis Emandatus*, 1594 (detail, fig. 6).
Page 24: Peter Paul Rubens, *Man in Korean Costume*, ca. 1617 (detail, fig. 1).

Contents

Foreword

Looking East: Rubens's Encounter with Asia is published to accompany a milestone exhibition of the same name at the J. Paul Getty Museum. Both undertakings revolve around the Getty's large-scale chalk drawing *Man in Korean Costume,* ca. 1617, by the Flemish artist Peter Paul Rubens (1577–1640). As far as we know, this remarkable work is the earliest Western depiction of a person in Korean costume and has been considered noteworthy since it was made. The drawing was copied in Rubens's studio in the seventeenth century and circulated as a reproductive print in the eighteenth. Yet, despite its renown, there has been no consensus as to why the drawing was made or whom it may depict—and, in particular, whether he was Korean. Rubens's enigmatic subject has been associated with heathen priests in Goa, Siamese ambassadors visiting the English court of King Charles I, European Jesuits working in China, and most recently former Korean slaves who traveled to Italy or the Netherlands.

Much of the confusion about the identity of the figure arises from the narrow parameters by which the drawing has been previously studied. Using this work as a focal point, the authors of this volume provide the first thorough investigation of what Rubens would have known about Asia. Historians of both Asian and Western art elucidate the various contexts in which knowledge about each continent was exchanged during the early modern period, paying particular attention to how Rubens, through his Jesuit patrons in the cosmopolitan city of Antwerp, could have gained access to costume from Joseon dynasty Korea, which was at that time a tributary of China. The interdisciplinary approach of this book explores the artistic, religious, and mercantile contexts that fostered the initial encounter between Europe and Korea, thus situating the drawing within the fabric of

cultural history and reaching a more nuanced understanding of one of the most compelling depictions of an exotic Eastern subject by a Western artist.

We are deeply grateful to all of the lenders to the exhibition, most especially to the National Museum and the National Folk Museum, both in Seoul, Korea, for their critical contributions. Due to the efforts of Stephanie Schrader, associate curator in the Department of Drawings, the Getty Museum has been fortunate to work closely with the Korean community in Los Angeles and in Seoul. In particular we would like to acknowledge the generosity of our sponsors BBCN Bank, Los Angeles, headed by Alvin D. Kang, Myung Hee Hyun, and Jimmy Lee. In our efforts to celebrate Korean art, history, and culture as seen through the perceptive eye and skillful hand of Peter Paul Rubens, we have embarked on our own cross-cultural exchange that we hope will be equally productive.

Timothy Potts, Director
The J. Paul Getty Museum

Acknowledgments

This book accompanies the exhibition *Looking East: Rubens's Encounter with Asia* (March 5 to June 9, 2013), organized by the J. Paul Getty Museum. As I embarked on the first in-depth study of Rubens's drawing *Man in Korean Costume*—which involved knowledge of Korean art, costume, culture, and history—I was assisted by many colleagues. Professor Burglind Jungmann at the University of California at Los Angeles, the only professor of Korean art in America, has been indispensable. Working with Burglind has been a model of collaboration, and I am extremely grateful for her sharing her expertise. Kim Young-Jae from the National Folk Museum in Seoul, an expert in Joseon dynasty costume, has provided the first thorough analysis of the costume depicted by Rubens. With her contribution it becomes clear just how much artistic license is at play in Rubens's drawing. I would also like to recognize Christine Göttler's new research on the city of Antwerp, as it demonstrates how Rubens's interest in the exotic and foreign was fostered by the cosmopolitan city in which he lived and worked.

Enthusiastic staff members of the *Korean Daily News* in Los Angeles and prominent members of the Korean community, such as Chester Chang, Indong and Kyungja Oh, and Myung Deering, made me aware of the importance of Rubens's *Man in Korean Costume* to Koreans. An initial research trip in Korea in 2010 would not have been possible without the costume historian Park Hyun-Jung from Jeonju University and Lee Myung Eun at Seok Juseon Memorial Museum at Dankook University. I would also like to thank the curators from Ewha Womans University Museum and Daegu National Museum for their research assistance. In my trip to secure the loans for the exhibition in 2011, I received a warm welcome from the National Museum in Seoul, and I would like to acknowledge

Lee Won-bok, Moon Dong Soo, and Lee Wonjin for their assistance. I would also like to recognize the generosity of Professor Ahn Hwi-joon; Yun Hyeong-sik and Choi Heeseon from the Korean Cultural Center; Bae Sung-won from the Korea Foundation; Lee Hyun-sook from Hanbook Nara; and the artist Kim Tae Soon.

The predominantly positive response to the loan requests was heartening, and many thanks are extended to our Korean, European, and American lenders, including the National Museum and the National Folk Museum, Seoul, and Yun Hyeong-sik, Haenam; the Metropolitan Museum of Art, the Morgan Library and Museum, and the New York Public Library, New York; Statens Museum for Kunst, Copenhagen; the British Library and the British Museum, London; the Nationalmuseum, Stockholm; the Kunsthistorisches Museum, Vienna; the Huntington Library, Art Collections, and Botanical Gardens, San Marino, California; and the Getty Research Institute, Los Angeles.

It is not an overstatement to say that without Jessie Huh, graduate intern in the Department of Drawings at the J. Paul Getty Museum, this project would have never happened. Jessie worked tirelessly as my translator in Korea and in Los Angeles. She not only assisted me with research for both of my essays in this volume, but she also shepherded all the Korean loan paperwork and photography orders for images from Korean institutions and drafted half the labels for the exhibition. I would also like to thank Lee Hendrix, senior curator of Drawings, for giving me the time to develop this project properly and for her help in shaping the research. I am also grateful for the efforts of many staff members at the Getty Museum, including Quincy Houghton and Susan McGinty in Exhibitions; Cherie Chen, Leigh Grissom, Sally Hibbard, Travis Miles, and Betsy Severance in

the Registrar's Office; Robert Checchi, Merritt Price, and Irma Ramirez in Exhibition Design; Kevin Marshall and his team of preparators; Stephen Heer, Lynne Kaneshiro, and Nancy Yocco in Paper Conservation; Maite Alvarez, Cathy Carpenter, and Peter Tokofsky in Education; Laurel Kishi in Public Programs; and Nina Diamond and Chris Keledjian in Collections Information and Access. James Cuno, president and CEO of the J. Paul Getty Trust, and John Giurini, assistant director of Museum Communications and Public Affairs, must be recognized for their tireless efforts to secure funding for the exhibition. I would also like to thank Professor Peter Mancall, director of the Early Modern Studies Institute, and Professor David Kang of the Korean Studies Institute, both at the University of Southern California, for their support of the symposium associated with the *Looking East* exhibition.

This book received its initial support from Rob Flynn, editor in chief at Getty Publications; and Kara Kirk, publisher, also showed a keen interest. Special thanks go to Dinah Berland, editor; Jim Drobka, designer; Elizabeth Kahn, production coordinator; and Pam Moffat, rights assistant. Consultants for this project also include Diana Evans, translator; Naomi Long, manuscript editor; Mark Rhynsburger, proofreader; and Theresa Duran, indexer. —SS

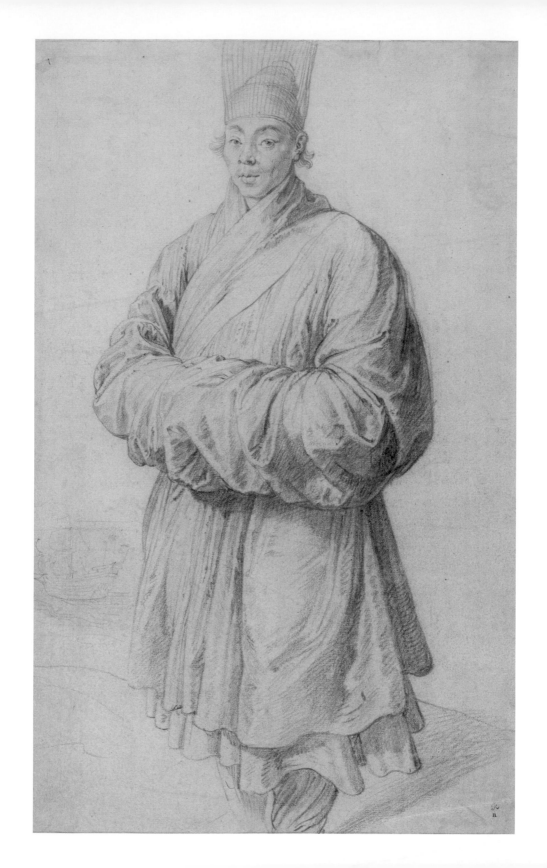

The Many Identities of Rubens's *Man in Korean Costume*: New Perspectives on Old Interpretations

Stephanie Schrader

In his *Man in Korean Costume* (fig. 1), now in the collection of the J. Paul Getty Museum, Peter Paul Rubens (1577–1640) deviated from the familiar garments of his native Antwerp to convey the foreign attire of an Asian kingdom little known to him. Although Rubens used a variation of this figure in a 1617 painting, the Getty drawing is by no means simply a quick, small sketch of exotic attire. The cascade of shimmering silk robes and the curious headdress that allows light and air to pass through it are meticulously rendered on a large scale. The tightly cropped figure with a piercing gaze in the immediate foreground conveys a forceful presence. The cast shadow at right, together with the rosy red cheeks, ears, and lips, further animate the figure. The compelling Getty drawing has captured viewers' attention for centuries. Although the current title of the drawing provides a straightforward identification, its association with Korea did not occur until the twentieth century.[1] In short, *Man in Korean Costume* is a captivating yet puzzling work of art that has engendered an array of narratives to explain how a European artist could have made such a lifelike portrayal of a man in Asian dress. This essay traces the critical and artistic reception of the drawing in both words and images.

Rubens often included exotic costumes and headdresses to enhance the dramatic impact of his historical and religious paintings. His *Adoration of the Magi* (fig. 2), now in the Museo del Prado, demonstrates how the inclusion of foreign dress helps transform the humble stable setting into a grandiose spectacle.[2] In this large, crowded composition a black Magus gazes directly at the viewer. His velvet jacket, embroidered gown, and fanciful headdress bedecked with jewels and

FIGURE 1 Peter Paul Rubens (Flemish, 1577–1640), *Man in Korean Costume*, ca. 1617. Black chalk with touches of red chalk in the face, 38.4 × 23.5 cm (15⅛ × 9¼ in.). Los Angeles, J. Paul Getty Museum, 83.GB.384

1

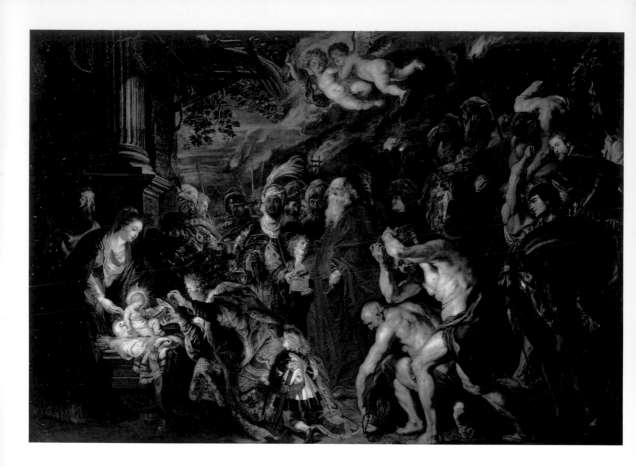

FIGURE 2 Peter Paul Rubens, *Adoration of the Magi*, 1609–28. Oil on panel, 355.5 × 493 cm (139 15/16 × 194 1/8 in.). Madrid, Museo del Prado, 1638

FIGURE 3 Peter Paul Rubens, *Robin, the Dwarf of the Earl of Arundel*, 1620. Black and red chalk, reinforced with pen and brown ink, traces of white chalk heightening (collar, sleeves, glove), 40.8 × 25.8 cm (16 1/16 × 10 3/16 in.). Stockholm, Nationalmuseum, 1913/1863

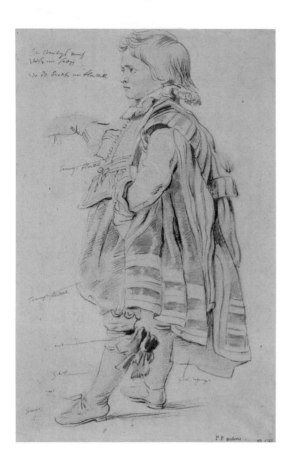

bird plumage call attention to his elevated status. Together with the large, curious camels, the king's exotic costume gives the sense of his journey from afar, suggesting that the birth of the baby Jesus, the "Prince of Peace," had ramifications around the globe.

In his large-scale costume drawings Rubens typically included brief notes specifying details about the color and length of foreign attire and sometimes even identified the garments individually. For example, when preparing a painted portrait of the English countess of Arundel and members of her court, Rubens made a drawing of the clothing worn by the court jester, a dwarf named Robin (fig. 3). In his detailed depiction of the jester's costume, Rubens inscribed comments in Flemish specifying the colors and materials of individual garments: "The mantle may be red satin; the pants red velvet; yellow lining."[3] Rubens referred to his annotated drawing for executing the painting, which he made after the countess and her retinue had left Antwerp and returned to England.

Despite its compelling representation of numerous pleats, scintillating high-lights, and the voluminous quantity of expensive fabric, Rubens's portrayal of exotic costume in the Getty drawing notably lacks notations and salient details. For example, it does not include inscriptions about the colors, lengths, or names of garments. Odder still for a costume study is that the image ends above the feet, without revealing the subject's footwear, and the pants are depicted in a cursory manner. The imposing figure himself appears alone in the center foreground with the outlines of a merchant ship visible in the distant background at left along with two faint, undulating lines behind the figure, evocative of a shoreline (fig. 4). These details allude to maritime travel from a foreign land, but they do not help specify the origins of the individual or his attire. Equally noteworthy in this seemingly documentary depiction is the indeterminate nature of the figure's facial features (fig. 5). Less prominent than the voluminous folds of the exotic costume and curious headdress, the figure's face, with its high cheekbones, flat nose, heavily arched eyebrows, and deeply set elliptical eyes, connotes the physiognomy of an Asian person in a general way, but the drawing does not provide enough evidence to be able to definitively establish the figure's identity as Korean.

In 1935 Clare Stuart Wortley claimed that the costume in the Getty drawing was Korean but without supplying details supporting this identification.[4] Presumably she recognized in the voluminous overcoat with a low waist, pleated skirt, and long sleeves the *cheollik* (see fig. 19) worn in Korea before the eighteenth century.[5] In addition, the transparent headdress in the Getty drawing resembles a Korean *banggeon* (see fig. 11), an open headdress in a square format woven from horsehair and worn by Confucian scholars at home.[6] It is important to note that during the time Rubens made his drawing, Joseon Korea (1392–1910) had a particularly close tributary relationship with Ming China (1368–1644). As in earlier centuries, Confucian thought as well as Chinese rituals, ranking systems, and dress styles came to Korea via China.[7] Apparently, Wortley did not find the close relationship between Korean and Chinese dress a hindrance when she made her identification. Her briefly stated, matter-of-fact opinion that the Getty drawing depicts Korean costume has been repeated in every publication about the sheet since 1935. In 1983, after the Getty acquired the drawing at auction, the Korean community supported the identification of the costume in a notice published in the *Korean News Review*.[8]

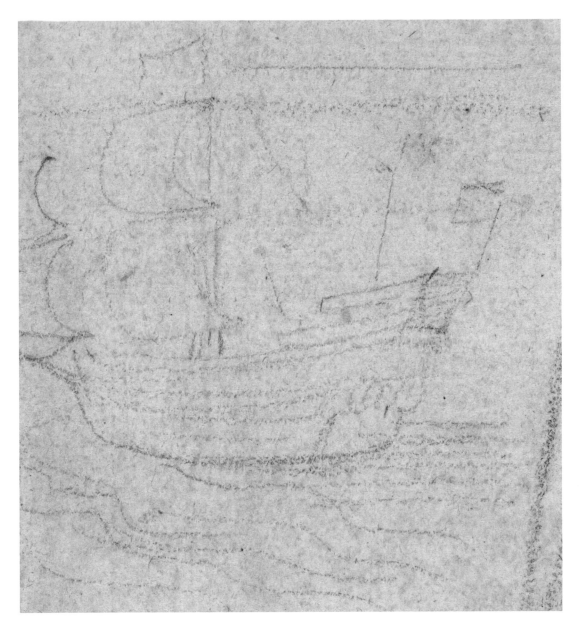

FIGURE 4 Peter Paul Rubens, *Man in Korean Costume* (detail, fig. 1), showing the boat in the background

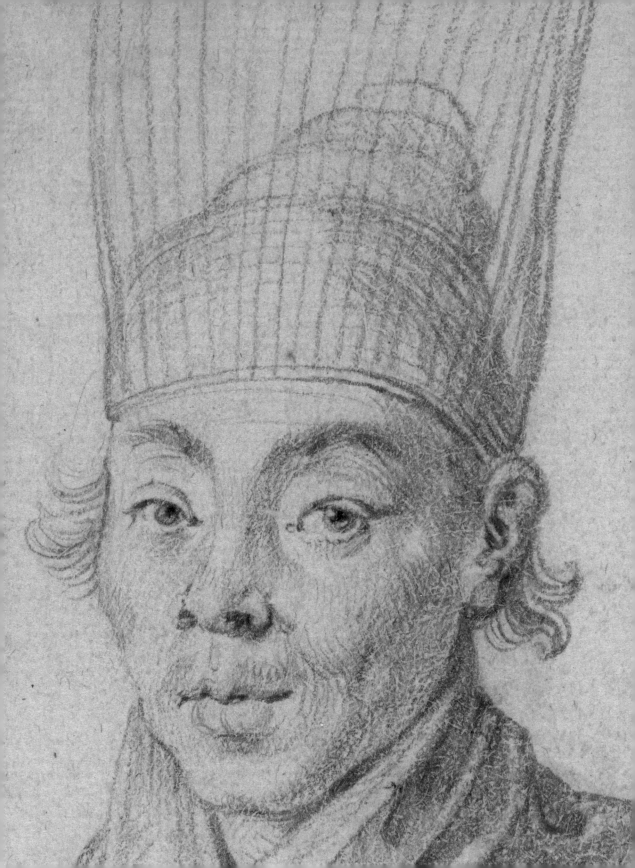

European knowledge of the distinct costumes and customs of Korea was by no means commonplace in the 1600s. Unlike China and Japan, which had contact with Europe through trade, Korea did not have official diplomatic relations with the West until the nineteenth century, and its only link to Europe came indirectly through its East Asian neighbors.[9] Despite travel accounts that stirred curiosity about Asia in the late sixteenth century, Korea was barely known to Europeans at this time. The best-known world map of this period, published by Abraham Ortelius in 1584, does not specify Korea under any name; instead, it leaves the area near the Chinese Liao-dong Peninsula blank and characterizes it as "unknown territory."[10] Korea finally appeared as a peninsula in Petrus Plancius's *Orbis Terrarum* (Map of the World) of 1594 (fig. 6). The editions of Jan Huygen van Linschoten's *Itinerario, Voyage ofte Schipvaert . . . naer Oost ofte Portugaels Indien* (Itinerary, voyage or navigation . . . to East or Portuguese India) from 1599 onward include this map. Linschoten's account of Asia from the book's 1596 edition, however, contradicts the map's depiction of Korea as a peninsula and describes it as the "Insula de Core" (Island of Korea), a big island somewhat above Japan and not far from the coast of China with "no certainty concerning its size, people, nor what trade there is."[11]

European misunderstanding about Korea prevailed into the latter half of the seventeenth century. In 1653 a ship from the Dutch East India Company (in Dutch, Verenigde Oost-Indische Compagnie [VOC]) loaded with pepper, sugar, and deerskins was headed for the Japanese island of Deshima and shipwrecked on Jeju Island in Korea. The survivors were taken prisoner and remained in captivity in Korea for thirteen years. After their escape the ship's secretary, Hendrik Hamel, published a report of the shipwreck, providing the first European description of Korea. Hamel's account of his initial encounter with the inhabitants of Jeju is telling; judging by their clothing, Hamel deduced that they had landed on an island inhabited by Chinese pirates.[12] The lack of a distinct notion of Korean people and their clothing is further conveyed during Hamel's journey back to the Netherlands in 1668. The Dutch agent posted in Nagasaki described the Dutch merchants who

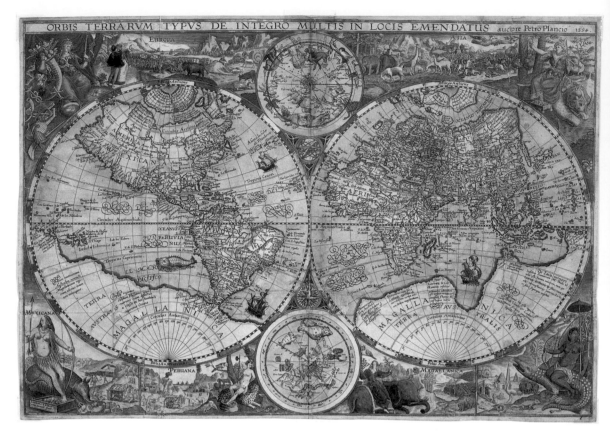

FIGURE 6 Petrus Plancius (Dutch, 1552–1622),
*Orbis Terrarum Typus De Integro Multis
in Locis Emendatus*, Amsterdam, 1594.
Hand-colored map, 41 × 58.5 cm
(16⅛ × 23¹⁄₁₆ in.). San Marino, California,
The Huntington Library, 132666

returned unexpectedly from Korea as being "dressed in a wondrous way with a boat of a strange fashion."[13] Thus when Rubens made the Getty drawing in 1617, its European viewers would have considered the costume he depicted to be wondrously foreign but not identifiably Korean.

During the last two decades the Rubens drawing has come to represent much more than a generic depiction of a man wearing Korean costume, and attempts have been made to associate the figure with a historical person. Most recently, Ji Myeongsuk, a Korean historian at Leiden University who specializes in Dutch and Korean exchanges in the early modern period, postulated that the figure depicts an anonymous Korean who appears to have worked for a Dutch merchant in Japan.[14] Ji identified the unnamed Korean mentioned in two letters written to the VOC governor general of Batavia (modern-day Jakarta) in February 1628 as the "Joseon Man" after the dynasty that ruled the kingdom of Korea from 1392 to 1910.[15] The letters make brief reference to an undated trade dispute filed in Japan by the mesne lord of Hirado against the Dutch for piracy, in which a Korean served as a witness.[16] Ji interpolates that this "Joseon Man" was brought to Japan during Hideyoshi's invasions of Korea in 1592 and 1598, when approximately one hundred thousand Koreans were taken as slaves.[17] According to the VOC letters, this man became the attendant for the Dutch merchant, Jacques Specx,[18] who served as the superintendent of trade and head of the factory on the Japanese island of Hirado from 1606 to 1621.[19] Ji assumed that Specx hired the "Joseon Man" as a translator in order to facilitate trade relations in East Asia.[20] The VOC correspondence cursorily mentions that the Korean "was in Zeeland [a province of the Netherlands] as a crew member of a Dutch vessel."[21] Ji postulates that the "Joseon Man" accompanied Specx on his trip to Indonesia in 1613. He subsequently traveled independently to the southwest Dutch province of Zeeland around 1615 and returned to Japan to work again for Specx and serve as a witness before 1628.[22]

The presence of the "Joseon Man" in Zeeland, a major locus for the VOC, thus brings a Korean individual closer to Rubens than was previously thought conceivable, since Rubens's native Antwerp lies only some forty miles from Zeeland. His capacity as "Specx's attendant" and witness in a trade dispute indicated that he would have carried the rank of a military officer or a governmental official

who spoke both Dutch and Japanese.[23] Accordingly, Ji speculates that the "Joseon Man" had become a substantial personage, worthy of a depiction by Rubens. The costly and opulent silk clothing that the figure wears in Rubens's drawing would have been consonant with his official status. Thus Ji consolidates her theory that Rubens's figure is a portrait of the "Joseon Man."

In Ji's account, the portrait of a "Joseon Man" drawn by Rubens memorialized a specific cross-cultural encounter between Korea and Europe—an encounter in which a Korean attendant to a VOC official achieved sufficient status to warrant his portrait being drawn by one of the day's most famous artists. According to Ji's line of thinking, the very existence of this portrait redounded to the glory of the "Joseon Man" and by implication to that of Korea in general, since Rubens's sitters came exclusively from the ranks of Europe's nobility and otherwise celebrated and distinguished individuals. A portrait of the "Joseon Man" would thus visually document a Korean active in international trade, in contradiction to the prevailing belief that Korea was closed to the West until the nineteenth century. Regarding itself as the custodian of Chinese culture and traditions, Korea was known as "Little China," and voluntarily accepted the hierarchical relationship with Ming China and paid on average tribute three times a year during Korean diplomatic missions to Beijing.[24] Korea's relationship with Japan was entirely different. The invasions by the Japanese and subsequent slavery of many thousands of Koreans resulted in the shutting of Korea's borders to outsiders. Thus the idea that Rubens made a portrait of a Korean after a period of Japanese colonization and Chinese subordination has assumed nationalistic implications. To the Korean advocates of this theory, the Getty drawing affirms that Europeans had firsthand knowledge of Korea in the early seventeenth century. This is no small interpolation of history considering that the first detailed European account of Korea was only published in 1668.[25] Ji's reading of the drawing has understandably resonated with the national identity of today's South Koreans as they ever more successfully participate in the global economy and culture, and as they recapture national pride in a historical past so ravaged by exterior forces.

Unfortunately, scant evidence in the VOC correspondence about the "Joseon Man" makes identification of the Getty drawing as a portrait of this individual merely speculative. While the early documents have this Korean working as a crew

member on a Dutch vessel in Zeeland, they provide no firm basis for concluding that Rubens met him. What the drawing does reveal, however, are more general realities about Korea's relationship with the outside world. Its borders were likely more porous than official policy then stipulated, and furthermore Korea's fraught relationship with Japan may have inadvertently resulted in Korea being introduced to Europe. Indeed, it seems likely that due to the presence of Korean slaves in Japan and the burgeoning trade relationship between the Japanese and the Dutch in the seventeenth century, the perception of Korea, geographically and culturally, entered the collective European imagination.

Another historical figure associated with the Getty drawing is a freed Korean slave thought to have resided in Rome around 1600.[26] Antonio Corea (i.e., Korea) appears in a travel account written by a Florentine merchant and slave trader Francesco Carletti (1573–1636). Encouraged by the grand duke of Tuscany, Ferdinando de' Medici, to cut into the Portuguese, Spanish, and Dutch monopoly on trade with Asia, Carletti joined his father on a business venture in a hostile, competitive environment. During his travels around the world from 1594 to 1602, Carletti appears to have made copious notes about the exotic places and people he encountered.[27] When he returned to Florence in 1606 he recounted his observations to the grand duke and then recorded in writing what he had orally related. Although the original manuscript is now lost, a version of Carletti's journey was published posthumously. Carletti's *Ragionamenti del mio viaggio intorno al mondo* (Considerations of my journey around the world) (Florence, 1701) provides a vivid account of how Europeans interacted with Asians in the early modern era.[28] As a merchant engaged in the trafficking of slaves for profit, Carletti had many firsthand encounters with Asians, and his travel account provides an absorbing description of exotic cultures for a European audience.

Carletti's *Ragionamenti* reveals basic geographical knowledge of Japan and China as well as some familiarity with the cultural, political, and linguistic diversity of these countries. He was also aware of the Japanese invasions of Korea that resulted in "an infinite number of [Korean] men and women, boys and girls, of every age . . . [being] sold as slaves at the very lowest prices."[29] Carletti purchased five Korean slaves in Nagasaki "for little more than twelve *scudos*."[30] Yet compared to the seventy-five Moorish slaves he had purchased earlier in Cape Verde and

would later sell in Cartagena, the five Korean slaves he acquired were relatively few. From Carletti's brief description, the purchase of these Korean slaves seems to have been motivated more by price than by the potential for profit.

Carletti characterized himself as "a pious and professed Christian."[31] He also described his friendships with Italian Jesuit missionaries, which led to a completely unconfirmed claim that Carletti himself was a priest.[32] All that can be certain is that the Italian merchant found it necessary that his Korean slaves convert to Christianity; he mentions in passing that he "had them baptized before taking them to Goa."[33] Compared to the other descriptions of Christian conversions in Carletti's text, the baptism of the Korean slaves was not a matter of free choice. Thus the subsequent associations of the Korean slaves with devout Christianity also cannot be substantiated from the travel narrative.[34] On arriving in the Portuguese colony of Goa (in modern-day India), Carletti set the slaves free. Carletti himself does not elaborate on his actions. Either he felt remorseful about making a profit of flesh and blood, which seems unlikely given his profession, or he thought, based on his earlier experience of buying slaves in Cape Verde and selling them for little profit in Cartagena, that their value as merchandise was decreasing.[35] Carletti concludes his discussion of Korean slaves by mentioning, "I brought one of them with me to Florence. I think today he is to be found in Rome, where he is known as Antonio Corea."[36]

Antonio Corea may be the same Korean servant described later in the *Ragionamenti*. When Carletti departed for Europe from Goa the day after Christmas in 1601, he was rich in silk, jewels, and spices. He traveled luxuriously on a Portuguese ship and brought aboard three servants—"one of the Japanese nation, a Korean, and the other a Mozambique Negro."[37] After the Portuguese ship was attacked and captured by a Dutch ship in Saint Helena, Carletti had to renegotiate his journey to Europe—a trip that resulted in the Dutch confiscating all of his goods and forcing him to leave his servants behind. According to Carletti, his Korean servant tricked the Dutchmen from Zeeland into taking him aboard their ship bound for Middelburg. In order not to be left in Saint Helena, the Korean hung on his neck Carletti's necklaces of the crucified Christ and *Ecce Homo*, and then plunged into the sea. Thinking the necklaces valuable, the Dutchmen took the Korean servant aboard their ship, bound for Europe.[38] Once aboard, the

necklaces were quickly recognized by the sailors to be made of copper and not of great value. Instead of using this passage to praise the devout Christian faith of his Korean servant, Carletti only condemns the "heretical Dutch Calvinists" for lacking any interest in seeing "saints or even God Himself crucified" and mocks the Dutchmen for being duped by "my servant of the Korean nation."[39] The rest of the account is concerned with the legal battles Carletti fought in Middelburg for the return of his merchandise, his subsequent journey to Paris, and his final return to Florence in 1606. Carletti makes no further mention of the Korean servant. One can only presume that Antonio Corea accompanied Carletti first to France and then to Florence before he traveled independently to Rome.

The association of the Getty drawing with the slave Antonio Corea has captured the imagination of the modern-day Korean public. The possibility that the Getty drawing was a portrait of Corea was first mentioned by a reporter in a 1983 issue of the *Korean News Review*.[40] The theory was made popular when it appeared in a best-selling Korean novel *Beniseu ui Kaeseong sangin* (The Gaeseong Merchant of Venice), written by O Se-yeong in 2002.[41] It was later given more historical substantiation by Gwak Cha-seop, a Korean professor of early modern Italian history at Pusan University, in his *Joseon Man, Antonio Corea, Meets Rubens* (2004).[42] According to all three writers, Rubens encountered Antonio Corea during the artist's second stay in Rome from 1605 to 1608 and made a portrait of him. This theoretical identification of the Getty drawing is now broadly accepted in Korea, as it appears in contemporary Korean textbooks and has reportedly been the subject of a musical.[43]

Unlike the "Joseon Man" hypothesis, which is based on VOC letters, however loosely substantiated, the Antonio Corea identification depends solely on a posthumously published travel narrative that remains unsupported by existing archival documents. In fact, the only proof that Korean writers have provided to support that Antonio Corea actually lived in Italy is a group of about two hundred Koreans with the last name of Corea who today live in the town of Albi in Calabria.[44] Furthermore, it is difficult to substantiate that Rubens made the Getty drawing in Rome given what is known about the types of drawings the artist made when he visited there. From November 1605 to October 1608, Rubens was preoccupied with copying famous works of classical antiquity as well as compositions

of well-known Italian artists.[45] It is much more likely that Rubens made the Getty drawing years later in Antwerp in relation to an altarpiece he designed to celebrate Jesuit missionary work in Asia (see chap. 3, herein).

The recent attention to the Korean identifications has overshadowed the earlier, equally complex reception of Rubens's sheet. The drawing was celebrated in England since the eighteenth century when it assumed an entirely different identity. The Getty sheet was once part of the famous collection of the English painter Jonathan Richardson Senior (1667–1745) and his son Jonathan Richardson Junior (1694–1771), who bought the drawing at a sale of his father's collection.[46] Their ownership is recorded on the drawing itself by the collectors' marks—two capital Rs stamped on the bottom right-hand corner. The sale catalogue of Richardson Senior's drawings sold at auction on January 22, 1746, and on the following seventeen nights, shows that Rubens's drawing received special notice. Among the vast list of untitled drawings by Rubens, Bernini, Titian, Raphael, and so on, lot 41 was described as "Two, Rubens, Siamese priests."[47] One of these drawings is the sheet now in the Getty's collection; the other, now thought to depict a European Jesuit missionary wearing Chinese costume, belongs to an unknown, private collection.[48] With Richardson's 1746 inventory listing, the figure in the Getty drawing was established as a priest from the Asian nation of Siam (modern-day Thailand).

The Siamese identification voiced in Richardson's sale catalogue was given a new emphasis on June 17, 1774, when Captain William Baillie (1723–1810) made a reproductive print after the Getty sheet in the "crayon manner," an etching technique used to imitate chalk drawings (fig. 7).[49] As an amateur printmaker, art dealer, and connoisseur, Baillie made reproductive prints of well-known Dutch, Flemish, and French paintings and drawings in important English collections.[50] Among them was the one made after Rubens's drawing, which at the time was in

FIGURE 7 Captain William Baillie (British, 1723–1810), *Siamese Ambassador*, June 17, 1774. Crayon-manner etching, 49.8 × 32.4 cm (19⅝ × 12¾ in.). Gift of Hazlitt, Gooden & Fox Ltd. Los Angeles, J. Paul Getty Museum, 91.GE.62

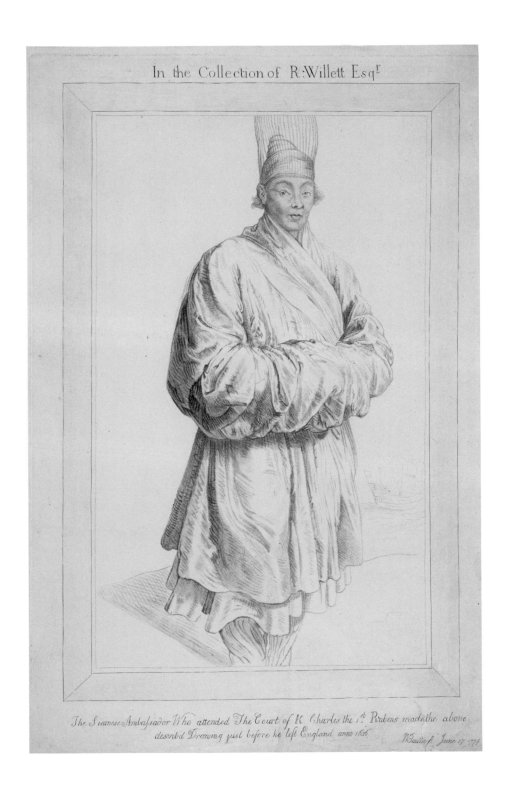

In the Collection of R: Willett Esqr

The Siamese Ambassador Who attended The Court of K. Charles the 1st. Rubens made the above
described Drawing just before he left England anno 1636. W Baillie f. June 17 1774

the collection of Ralph Willet, Esq. (1719–1795), whose name appears across the top of the print. Willet was the son of a sugar plantation owner who had made an immense fortune in the West Indies. In 1751, after coming into his inheritance, Willet purchased the estate of Merly in Dorset. In addition to erecting a handsome classical house there, he built a notable collection of printed books, prints, and drawings.[51] Baillie took great pride in mastering the style of the well-known artists he imitated. He also disseminated knowledge about the works he copied by selling his prints on a subscription basis. His most notable act of print publishing occurred shortly after he reproduced Rubens's drawing. In 1775 he reworked the original plate of Rembrandt's *Hundred Guilder Print* and charged his subscribers the high price of four *guineas* for an impression.[52] In the case of Rubens's figure, Baillie embellished Richardson's earlier Siamese identification with an inscription at the bottom margin of the print: "The Siamese Ambassador Who attended The Court of King Charles I. Rubens made the above described drawing just before he left England *anno 1636*." Baillie's print thus circulated the Siamese identification among a wider audience. In only twenty-eight years, the "Siamese priest" owned by Richardson had become a "Siamese ambassador," which through the print medium was to be seen by a broader public.

In addition to widely disseminating Rubens's striking depiction, Baillie's mirror-image of the drawing simultaneously incorporated the English artist's own interpretations of several passages. Misinterpreting Rubens's summary and allusive passage, Baillie transformed the legs of the drawn figure into two truncated leg stumps. He shaded the small face rather darkly, thereby increasing its prominence, and moreover lengthened the tall, transparent, horsehair headdress even further, bowing it slightly to the right. The overall result of these slight alterations is an elongated interpretation of Rubens's figure with a dark "Siamese" face. Baillie's Siamese identification was accepted in every publication that discussed the drawing until 1935, when Wortley proved that there was no visit by a Siamese embassy to the English court in 1636.[53] The link of the Getty sheet to Siam can further be disproven on the basis of costume. From a description of a Siamese ambassadorial visit to the Hague in 1604 and depictions of a Siamese embassy to the court of Versailles in 1686, it can be determined that the Siamese wore conical headdresses that were not made of horsehair.[54]

Like the previously discussed identifications of Rubens's figure as Korean, Baillie's promotion of its identity being that of the Siamese ambassador visiting the court of King Charles I was informed by his nationalistic point of view. With his inscriptions on the reproductive print, Baillie put Rubens's compelling drawing into service of the glorious English crown and highlighted the great artist's stay in England. The captions also advertised the amateur artist's insider knowledge of ownership of Rubens's drawing, privileging the drawing's place in Willet's collection. Moreover Baillie excluded the earlier ownership by leaving out the collectors' marks of Richardson Senior and Junior in his reproduction. From Willet's own description of Merly House's interior decorations, it appears that the collector and printmaker were like-minded in their desire to glorify England. According to Willet, "No Country hath done more for the Advancement of Knowledge than Great Britain; no Country in which the human Mind, unfettered by Restraints, is left more at Liberty to cultivate, and therefore more likely to improve its great Powers."[55]

An earlier artistic reception, which is the first known copy of the Getty drawing, is a red-chalk excerpt of the face drawn by Rubens's pupil Willem Panneels (ca. 1600–after 1634) (fig. 8). From 1628 to 1630, that is, during Rubens's lifetime, Panneels removed approximately 250 drawings from Rubens's *cantoor* (locked office), which he assiduously imitated for his own edification.[56] Gathering pictorial material that he could later use as visual sources, Panneels was very specific about the types of drawings he copied. He categorically preferred Rubens's anatomical studies, generic head studies, drawings made after the antique, drawings made after Italian masters, animal studies, mythological subjects, scenes from the life of Christ, and non-biblical religious allegories.[57] Panneels seldom copied his master's full compositions, but instead focused on one aspect, as one finds in his partial copy of the Getty drawing. Interestingly, he did not imitate Rubens's portrait drawings or costume studies.

Panneels's copy of the head of the Getty figure clearly elucidates how Rubens's pupil reacted to his compelling depiction, incorporating his own interpretations and alterations. In making a copy of the Rubens drawing in question, Panneels quoted the head only, eliminating both the headdress and costume. Mining the Getty drawing for its didactic potential, he emphasized the three-dimensional quality of the face. Panneels employed strong contour lines and

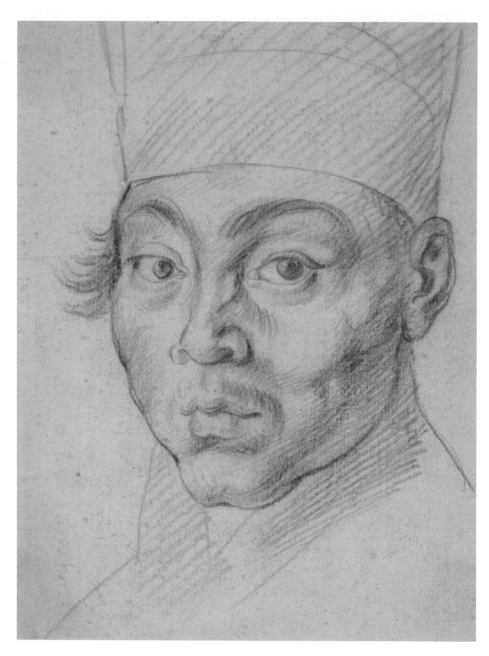

FIGURE 8 Willem Panneels (Flemish, ca. 1600–after 1634), *Head of Man in Korean Costume*, 1628–30. Red chalk with black chalk underdrawing, 16.4 × 12.1 cm (6½ × 4¾ in.). Copenhagen, Statens Museum for Kunst, KKSgb7839

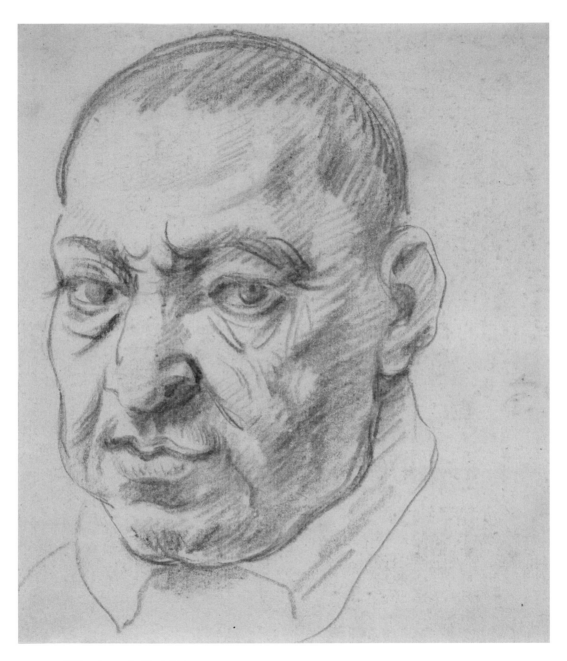

FIGURE 9 Willem Panneels, *Head of Man*,
1628–30. Red chalk with black
chalk underdrawing, 16.4 × 14.1 cm
(6½ × 5⁹⁄₁₆ in.). Copenhagen, Statens
Museum for Kunst, KKSgb7838

exaggerated the square jawline, fleshy lips, and broad nose. Instead of Rubens's subtle layering of black and red chalk, the pupil modeled the face with coarse, parallel hatching drawn in red chalk (see fig. 5). Panneels's copy of the head of the Getty figure was originally executed on the same piece of paper as another red-chalk head study (fig. 9), as evidenced by the single watermark cut in two.[58] This companion drawing, with its even coarser hatching, makes clear that the subtle modeling was of no interest to the pupil. Instead his bold pattern of light and dark turned Rubens's drawing into one of dramatic facial expression. Panneels did not appear to render his subject with knowledge of a specific nationality. Rather he celebrated the exotic face for its expressive qualities, remaining silent about the identification.

To analyze previous interpretations of Rubens's *Man in Korean Costume* is to come to the conclusion that this is a powerful work of art that prompts many more questions than it answers. The various mythologies constructed around the Getty drawing from the seventeenth century to the modern day constitute a remarkable blend of fact and fantasy as well as understanding and misunderstanding about Rubens, the artist, and Asia, his subject. These narratives also raise important issues of exoticism and globalization inherent to the depiction itself. As explored throughout this volume, Rubens's captivating portrayal of an encounter with Asia is neither a straightforward costume study, nor a document of a historical event, nor a portrait of a specific sitter. Drawing in a virtuosic manner, Rubens portrayed a figure in Korean costume the way his seventeenth-century European audience most likely would have imagined him—as alluringly exotic and foreign, a wonder to behold but defying categorization.

NOTES

I would like to thank Kristen Collins, Lee Hendrix, Jessie Huh, Louis Marchesano, Naoko Takahatake, and Anne Woollett for their insightful commentary on various drafts of this essay.

1 As this essay demonstrates, the title of the Getty drawing, which was not established during Rubens's lifetime, has changed over the years. When the Getty purchased the drawing in 1983, it was titled "Man in Korean Costume." When it was published in the Getty's catalogue in 1988, it was called "Korean Man," based on a notice in the *Korean News Review* that associated the figure with a Korean slave named Antonio Corea (see note 8). Given the current state of research outlined in this essay, the earlier identification, or the more generic one, has now been deemed more appropriate.

2 See Alejandro Vergara, ed., *Rubens: The Adoration of the Magi* (Madrid, 2004); and Jean Michel Massing, "The Black Magus in the Netherlands from Memling to Rubens,"

in *Black is Beautiful: Rubens to Dumas* (Zwolle, Neth., 2008), pp. 44–46.

3 "*Het Wambuys vermach wesen root sattyn ende de broeck root flouwell; geel vudringhe.*" See Julius Held, *Rubens: Selected Drawings* (Mt. Kisco, NY, 1986), pp. 124–25.

4 Clare Stuart Wortley, "Rubens's Drawings of Chinese Costume," *Old Master Drawings* 9 (1934), p. 42n1.

5 For a discussion of *cheolliks*, see *Myeongseon* [Selection of famous people: Traditional costume], vol. 2 (Seoul, 2004), pp. 85–99; and Gwak Cha-seop, *Joseon cheongnyeon Antonio Korea, Rubenseu reul mannada* [The Joseon man, Antonio Corea meets Rubens] (Seoul, 2004), pp. 88–100.

6 For a discussion of these horsehair head-dresses worn in Joseon dynasty Korea, see *Myeongseon* [Selection of famous people: Traditional costume] (note 5), pp. 23–38; and Yang Jin-sook, "A Study on Types of Gwan," *Arts of Asia* 35 (January–February 2005), pp. 75–81. For an extensive discussion of how the Getty drawing relates to sixteenth-century Korean costume, see Kim Young-Jae, chap. 2, herein.

7 See *Myeongseon* [Selection of famous people: Traditional costume] (note 5), p. 19.

8 "Who Was the Korean Model for Rubens?" *Korean News Review*, December 10, 1983, p. 25.

9 Vibeke Roeper and Boudewijn Walraven, eds., *Hamel's World: A Dutch–Korean Encounter in the Seventeenth Century* (Amsterdam, 2003), pp. 29–36.

10 Boleslaw Szcześniak, "Matteo Ricci's Maps of China," *Imago Mundi* 11 (1954), p. 131.

11 Jan Huygen van Linschoten, *Itinerario, Voyage ofte Schipvaert naer Oost ofte Portugaels Indien* [Itinerary, voyage or navigation to East or Portuguese India] (The Hague, 1596), p. 37.

12 Gari Ledyard, *The Dutch Come to Korea* (Seoul, 1971), p. 17.

13 See Ledyard (note 12), p. 12.

14 Ji Myeongsuk and Boudewijn Walraven, *Bomulseom eun eodi e: Nedeollandeu gongmunseo reul tonghae bon hanguk gwaui gyoryusa* [Where is Treasure Island? Relationship between Netherlands and Korea, based on the Dutch East India Company's and other archives of the Dutch government] (Seoul, 2003), pp. 40–41.

15 The first letter is written by Cornelis van Neyenrode from the *Firando* on February 17, 1628, and the second letter is written by Pieter Nuyts from the *Thaiwan* on February 28, 1628. See W. Ph. Coolhaas, *Jan Pietersz. Coen: Bescheiden Omtrent Zijn Bedrijf in Indië*, vol. 7, no. 2 (The Hague, 1953), pp. 1227, 1257; and Ji and Walraven, *Bomulseom* (note 14), pp. 38–39.

16 See Coolhaas, *Jan Pietersz. Coen* (note 15), pp. 1227, 1257; and Ji and Walraven, *Bomulseom* (note 14), pp. 38–39.

17 See Roeper and Walraven, *Hamel's World* (note 9), p. 33.

18 See Ji and Walraven, *Bomulseom* (note 14), p. 40; and Coolhaas, *Jan Pietersz. Coen* (note 15), pp. 1227, 1257.

19 For Jacques Specx's bibliography, see http://www.vocsite.nl.

20 See Ji and Walraven, *Bomulseom* (note 14), p. 41.

21 See Coolhaas, *Jan Pietersz. Coen* (note 15), pp. 1227, 1257.

22 See Ji and Walraven, *Bomulseom* (note 14), p. 40.

23 See Ji and Walraven, *Bomulseom* (note 14), p. 45.

24 See Roeper and Walraven, *Hamel's World* (note 9), p. 32.

25 See Roeper and Walraven, *Hamel's World* (note 9); and Ledyard, *Dutch Come to Korea* (note 12).

26 See "Who Was the Korean Model?" (note 8); and Gwak, *Joseon cheongnyeon* (note 5), p. 5.

27 Francesco Carletti, *Ragionamenti di Francesco Carletti Fiorentino sopra le cose da lui vedute ne' suoi viaggi . . .* (Florence, 1701); Giuliano Bertuccioli, *Travels to Real and Imaginary Lands: Two Lectures on East Asia* (Kyoto, 1990), pp. 1–18; and Elisabetta Colla, "Southeast Asia 'Ethnic Minorities' in an Account by the Florentine Merchant Francesco Carletti: A 17th Century Manuscript," *Ethnic Minorities and Regional Development in Asia: Reality and Challenges*, edited by Huhua Cao (Amsterdam, 2009), pp. 33–48.

28 The original manuscript is now lost, but four copies of it are thought to exist. For a complete discussion of the various manuscripts, see Colla (note 27), p. 33; and Bertuccioli (note 27),

p. 7. For an English translation, see Herbert Weinstock, trans., *My Voyage Around the World by Francesco Carletti: A 16th Century Florentine Merchant* (New York, 1964). Weinstock based his translation on the manuscript now in the Biblioteca Angelica in Rome (Codex 1331), which is thought to have been written around 1619.

29 See Weinstock (note 28), p. 115.

30 Ibid.

31 See Weinstock, *My Voyage* (note 28), p. 13.

32 See Gwak, *Joseon cheongnyeon* (note 5), pp. 59–64.

33 See Weinstock, *My Voyage* (note 28), p. 115.

34 See Gwak, *Joseon cheongnyeon* (note 5), pp. 65–66.

35 Antonio Forte, "Appendix: Francesco Carletti on Slavery and Oppression," in *Travels to Real and Imaginary Lands: Two Lectures on East Asia*, edited by Giuliano Bertuccioli (Kyoto, 1990), p. 69.

36 See Weinstock, *My Voyage* (note 28), p. 115.

37 See Weinstock, *My Voyage* (note 28), p. 228.

38 See Weinstock, *My Voyage* (note 28), p. 239.

39 Ibid.

40 See "Who Was the Korean Model?" (note 8).

41 O Se-yeong, *Beniseu ui Kaeseong sangin: O Se-yeong jangpyeon soseol* [The Gaeseong Merchant of Venice] (Seoul, 1993).

42 See Gwak, *Joseon cheongnyeon* (note 5).

43 See Gwak, *Joseon cheongnyeon* (note 5), pp. 77–78.

44 Kim Sung-Woo, "A Village of the Coreas in Italy: Their Origin Was a Korean," *The Korea Times*, October 7, 1979; and Gwak, *Joseon cheongnyeon* (note 5), p. 68.

45 Jeremy Wood, *Rubens, Copies and Adaptations from Renaissance and Later Artists: Corpus Rubenianum Ludwig Burchard*, vol. 26. (London, 1987); and Marjon van der Meulen, *Rubens, Copies After the Antique: Corpus Rubenianum Ludwig Burchard*, vol. 23 (London, 1994–95).

46 For more information on Jonathan Richardson Senior as a collector of drawings, see Anne-Marie Logan with Michiel Plomp, "Collecting Rubens's Drawings," in *Peter Paul Rubens: The Drawings* (New York and New Haven, 2005), pp. 40–43; Carol Gibson-Wood, "Jonathan Richardson, Lord Somers's Collection of Drawings and Early Art Historical Writing in England," *Journal of the Warburg and Courtauld Institutes* 52 (1989), pp. 167–87; and Carol Gibson Wood, "'A Judiciously Disposed Collection': Jonathan Richardson Senior's Cabinet of Drawings," in *Collecting Prints and Drawings in Europe, c. 1500–1750*, edited by Christopher Baker, Caroline Elam, and Genevieve Warwick (Aldershot, Brit., 2003), pp. 155–71.

47 *A Catalogue of the Genuine and Entire Collection of Italian and Other Drawings, Prints, Models and Casts of the Late Eminent Mr. Jonathan Richardson, Painter, Deceased. Sold at Auction by Mr. Cock*, London, January 22, 1746–47, sold for the following seventeen nights (Sundays excepted), lot 41.

48 The author's later essay in this volume references the reproductive print made after Rubens's European Jesuit missionary wearing Chinese costume (see chap. 3, p. 62n9, herein).

49 C. G. Voorhelm Schneevoogt, *Catalogue des estampes gravées après P. P. Rubens, avec l'indication des collections où se trouvent les tableaux et les gravures* (Haarlem, Neth., 1873), p. 728.

50 For William Baillie's biography, see http://www.oxforddnb.com.

51 Tim Knox, "'A Mortifying Lesson to Human Vanity': Ralph Willet's Library at Merly House, Dorset," *Apollo* 152 (July 2000), p. 38. The Getty drawing was listed as lot 477 in the sale of Willet's collection on June 16, 1808, sold by his cousin John Willet. It was described as "a portrait of the Siamese ambassador to the Court of King Charles I." I would like to thank Peter Fuhring, Eric Hormell, and Martin Oldham for looking up and finding this sale for me.

52 Ibid.

53 Wortley searched the English State Papers, both East Indian and domestic, and the MS. Register of the Privy Council, wherein are recorded the privileged passes given to all ambassadors. There was mention of Rubens in 1630, but no mention of any Siamese. See Wortley, "Rubens's Drawings" (note 4), p. 41.

54 John Guy, "Siamese Embassies to the Court of the Sun King," in *Encounters: The Meeting*

of *Asia and Europe 1500–1800*, edited by Anna Jackson and Amin Jaffer (London, 2004), pp. 88–89.

55 See Knox, "Mortifying Lesson" (note 51), p. 43.

56 For a discussion of the *cantoor* and Panneels in general, see Kristin Lohse Belkin and Fiona Healy, *A House of Art: Rubens as Collector* (Antwerp, 2004), pp. 298–309; and Paul Huvenne, ed., *Rubens Cantoor: Een Verzameling Tekeningen Ontstaan in Rubens' Atelier* (Antwerp, 1993). For mention of the copy of the Getty drawing, see Jan Garff and Eva de la Fuente Pedersen, *Rubens Cantoor: The Drawings of Willem Panneels*, vol. 1 (Copenhagen, 1988), p. 119.

57 See Huvenne (note 56), p. 15.

58 See Garff and Pedersen, *Rubens Cantoor* (note 56), p. 119.

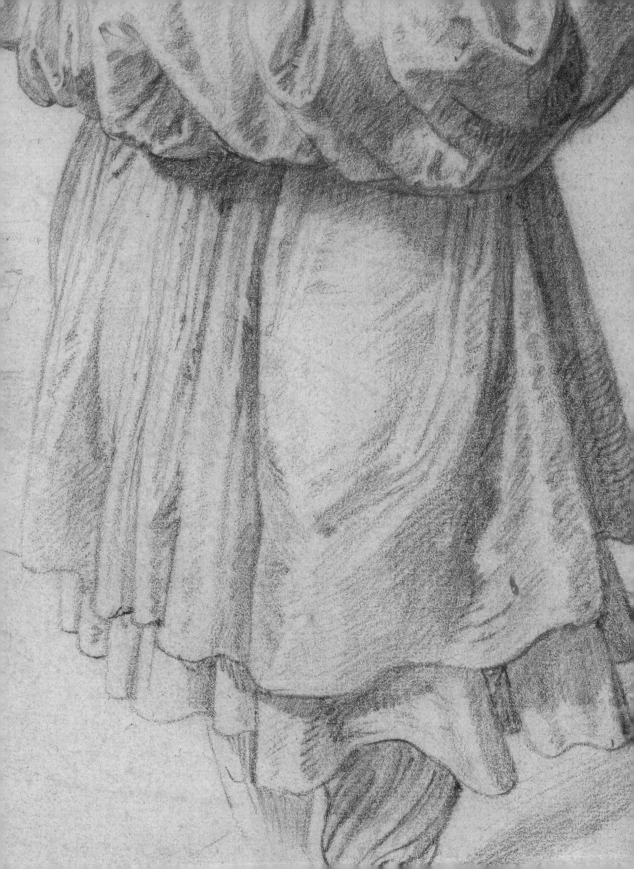

Looking at the Clothing of Rubens's *Man in Korean Costume*

Kim Young-Jae

Rubens's *Man in Korean Costume* (see fig. 1) is drawn in black chalk with touches of red. The pursed lips and direct gaze lend him a sense of propriety and quiet dignity. The affluence suggested by his silk garments and small, beardless face prompt the viewer to ponder the social rank of this man. His hands are clasped in front of his body and elegantly covered by long sleeves. The wavy hem of his garment seems to ripple in a soft breeze.

The date of this drawing coincides with the Joseon dynasty in Korea's history. Joseon dynasty dress styles can broadly be classified as Early Joseon, before the Imjin War (1592–98), and Late Joseon, after the second Manchu invasion (1636–37). Rubens's *Man in Korean Costume* was created in 1617, directly following the Imjin War; as such, I will examine the figure's attire on the premise that his style would be characteristic of Early Joseon, and I will try to deduce whether Rubens may have met his subject face-to-face. During a time when East–West exchange was infrequent, the unlikely discovery of a single drawing of a Joseon-era man in Europe seems to have greater meaning for the true protagonist of the drawing—Korea—than for the place where the drawing was discovered—Europe.

The Headdress of *Man in Korean Costume*

Rubens's figure wears a transparent headdress. Inside the hat a cloth is wrapped around the forehead with the hair ascending in three coils to form a topknot. During the Joseon dynasty, young males wore their hair in a single braid down their back, a style known as *chonggak*, or "the bachelor." At the time of their coming-of-age ceremony, they gathered their hair into a topknot. The fame of Korean topknots had reached China during the Goguryeo dynasty, the period

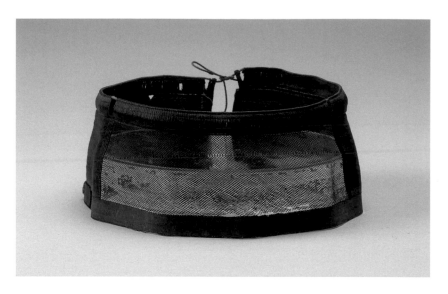

FIGURE 10 *Manggeon*, Joseon dynasty. Horsehair, 9.5 × 58 cm (3¾ × 22¹³⁄₁₆ in.). Seoul, National Folk Museum of Korea 국립민속박물관, 24790

before the Joseon dynasty. The Chinese dubbed the Korean topknot *chugyeol*, or club-shaped topknot.[1] When wearing a headdress, men first used a *manggeon* (fig. 10), or headband tied around the forehead, to gather their long, unbraided hair, making sure not to cover the eyes or hide the forehead. Then they collected the hair on the crown of the head and twisted it into a topknot. The forehead can be seen through the black *manggeon* because it is transparent, made of finely woven horsehair. When tying the upper set of strings of the *manggeon* around the head, the top part of it tightens to aid in keeping the hair neat and the topknot in place. Looking closely at the drawing by Rubens, however, reveals a divergence from tradition: he does not depict a transparent *manggeon* but instead shows a cloth headband covering the forehead (see fig. 5). During the Joseon dynasty a cloth headband was occasionally used to keep the hair in place, but not in conjunction

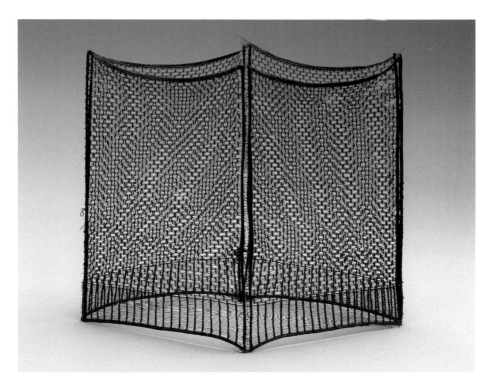

FIGURE 11 *Banggeon*, Joseon dynasty, 18th century.
Horsehair, 19 × 27 cm (7½ × 10⅝ in.).
Seoul, National Folk Museum of Korea
국립민속박물관, 2039

with a transparent headdress as seen in the drawing. Although the top part of the headdress in Rubens's drawing is not visible, it appears to be a *banggeon* (fig. 11), a square-shaped horsehair hat worn by Joseon dynasty men. This kind of headdress was generally only worn indoors, and when venturing out, the custom was to wear a proper hat that covered the whole crown of the head.

The Clothing Style of *Man in Korean Costume*

The length of the figure's overcoat is shorter than that of the garment worn underneath, which is also a type of outerwear. The coat's collar is in the Y-shape of a *jingnyeong* (coat) and tucks deeply underneath the arm at the left. The sleeves are nearly the same width across from shoulder to wrist and long enough to fully cover the hands, which are clasped in front of the body with elbows bent. The

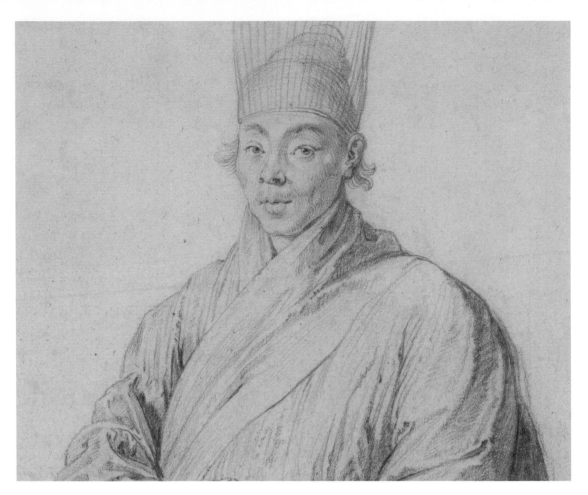

FIGURE 12 Peter Paul Rubens, *Man in Korean Costume* (detail, fig. 1), showing the collar

outer coat falls to the knees while the inner coat hangs below. Underneath the hem of the inner coat are pants.

In the drawing, the wide collar of the coat covers the neck and extends halfway to the shoulders (fig. 12). Joseon dynasty outerwear, however, did not exhibit collars of such great width. Even wide, double collars worn by men and women in the Joseon dynasty did not extend halfway or more to the shoulders (fig. 13). In traditional Korean clothing, collars were composed of three parts: the outer collar, the back collar, and the inner collar. The back collar in particular was tailored to the width of the neck. Joseon collars were worn high on the neck, akin to the turned-up

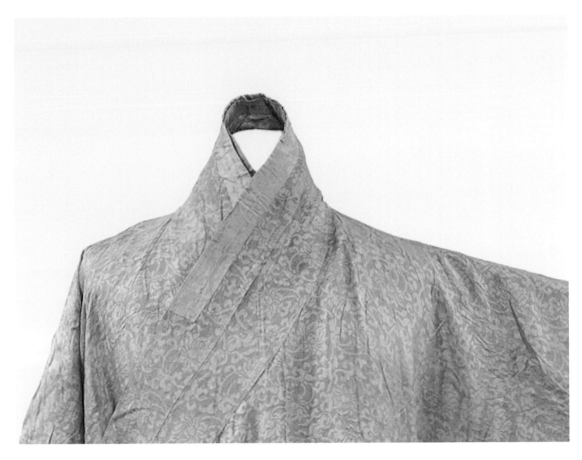

FIGURE 13 A *dapho* worn over a *cheollik* (detail,
fig. 16), showing the collar

collar of a Western suit. The three parts of the collar together extended all the way
around the neck and down toward the chest. Fashioning a collar that covered the
shoulders to the extent seen in the drawing would only be possible by making the
back collar very large. In Korea the back collar of traditional clothing was made to
correctly fit the proportions of the wearer's body: if the width of the back collar were
very narrow, it would appear too tight around his neck, and if the back collar were
too wide, the clothes would appear loose and would not stay in place. The back col-
lar must be tailored to the appropriate width in order for the clothes to fit the body
properly. Because the width of the back collar is measured by the size of the neck,

the collar seen in the drawing, extending as it does halfway or more to the shoulders, seems highly improbable to be the collar of a traditional Korean garment.

When looking at the overcoat just below the area obscured by the arms, one notices folds or pleats at left and a flat area without folds at right (see detail, page 24). The overcoat hangs a little shorter than the inner coat, and when compared to the hem of the coat seen underneath, the folds of the overcoat are fewer in number. Since there are fewer folds on the outer garment, one can speculate that the overcoat is made from one piece of fabric. Although the difference between the length of the outer garment and the inner garment would not have been as prominent in Joseon dynasty clothing as it is depicted in the drawing, it seems that Rubens intended to depict a noticeable difference in length when the two coats were worn together.

The sleeves in the drawing exhibit characteristics of the narrow type found in Early Joseon: they are very long, and the width of the sleeve is similar at the shoulder and the wrist. In the fifteenth century, narrow sleeves were the norm; in the sixteenth century, both narrow and wide sleeves were acceptable; and from the eighteenth century onward, very wide sleeves became common.[2] The narrow sleeve is somewhat smaller in diameter at the wrist than at the shoulder, while the wide sleeve broadens under the arm, curving as it progresses toward the wrist. In contrast, very wide sleeves descend from the underarm almost perpendicularly, so that the shape of the sleeve becomes a wide rectangle. In the drawing one cannot measure with certainty the width of the sleeve, but its seemingly uniform width suggests the narrow sleeves of Early Joseon. The sleeve at right appears to narrow slightly as it descends from the shoulder and tucks under, forming an acute angle near the elbow (fig. 14). However, just above the elbow, the folded-under material forms a circle around the arm. Thus it appears that these are not the long sleeves of the narrow type after all, but short sleeves that do not quite reach the elbow in length.

Underneath the short-sleeved outer coat is an inner coat with characteristically long sleeves. The inner coat also boasts a hem of a more uniformly wavy pattern than that of the overcoat, which is indicative of a wider skirt. It is possible to surmise that the uniform distribution of folds, or perhaps pleats, visible in the drawing exists throughout the inner coat.

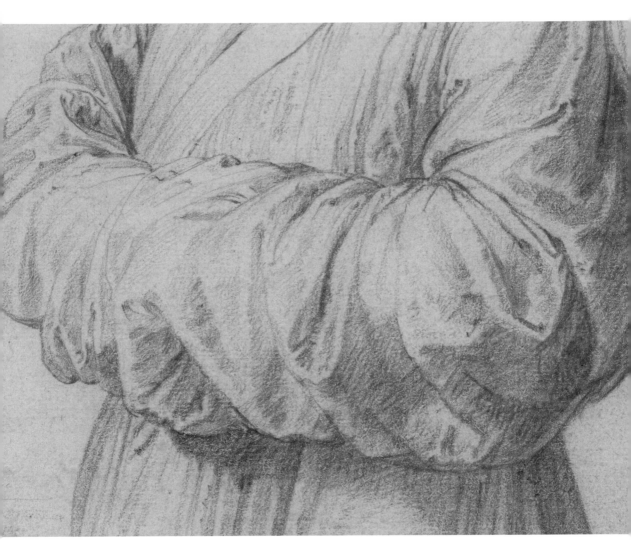

FIGURE 14 Peter Paul Rubens, *Man in Korean Costume* (detail, fig. 1), showing the figure's sleeves

Male Apparel in the Joseon Dynasty

The specific type of overcoat worn by men in Early Joseon comparable to the style seen in the *Man in Korean Costume* is called a *dapho* (pronounced *da-po*). Short sleeves are the distinguishing feature of the *dapho* (fig. 15). Joseon kings and officials wore the *dapho* over an inner coat called a *cheollik* (pronounced *chuhl-leek*) (fig. 16). The collar of the *dapho* is straight, the sleeves short; triangular or trapezoidal panels of material called *mu* are often attached to the sides below the waist, and the material is cut wide enough to completely cover the garment underneath the *dapho*. In the drawing, the flat appearance of the garment under the figure's arm at right, along with the gathered material at the lower right, indicate that Rubens was indeed likely depicting a *dapho* cut from one piece of material with *mu* attached to the sides. In the drawing by Rubens, the *mu* of the *dapho* accords with the area of the elbow at right, and the flat part underneath is similar to that of the spread-out *dapho*.

Although it appears that the figure wears a *cheollik* under his *dapho*, it is difficult to be sure since the characteristic elements of a *cheollik* cannot be identified with certainty in the drawing. However, taking into consideration customary Joseon dynasty garb as recorded in contemporary histories, it is probable that the garment underneath the *dapho* is a *cheollik*. *Joseon Wangjo Sillok* (*Annals of the Joseon Dynasty*) records that Joseon kings wore *cheolliks* for everyday wear, and all government officials, servants, court musicians, official clerks, military officers, and even commoners wore round-collar *cheolliks*.[3] An extant example of this combination was discovered when a Joseon dynasty military officer named Byeonsu (1447–1524) was exhumed and found wearing a *dapho* over a *cheollik*.[4] A *cheollik* worn with an *ip* (a hat; fig. 17), a *gwangdahoe* (a belt), and *mokhwa* (high boots; fig. 18) comprised the military uniform. The *cheollik* with its ample skirt was worn when military duties required agility, such as when guarding the king on royal outings, when dispatched as a foreign envoy, and in times of national crisis.

FIGURE 15 *Dapho,* excavated clothing of Byeonsu (1447–1524), early 16th century. Silk, H: 135 cm (53⅛ in.); W: 63 cm (24¹³⁄₁₆ in.); *hwajang* (length from center of back collar to the end of the sleeve), 46 cm (18⅛ in.). Seoul, National Folk Museum of Korea 국립민속물관, 20954. Important Folklore Material No. 264

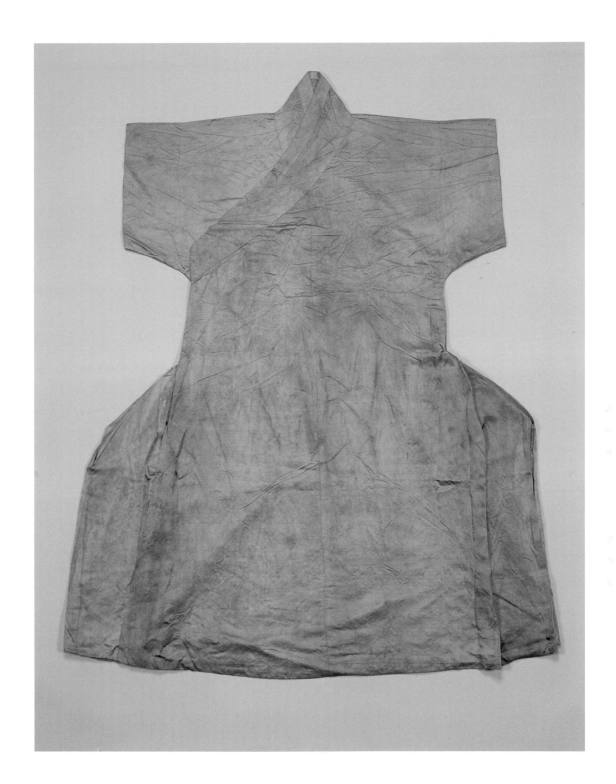

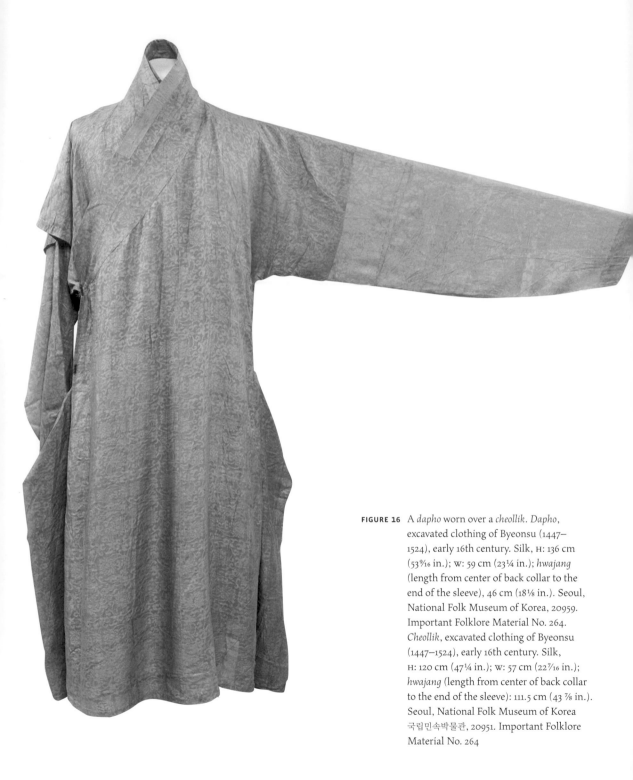

FIGURE 16 A *dapho* worn over a *cheollik*. *Dapho*, excavated clothing of Byeonsu (1447–1524), early 16th century. Silk, H: 136 cm (53⁹⁄₁₆ in.); w: 59 cm (23¼ in.); *hwajang* (length from center of back collar to the end of the sleeve), 46 cm (18⅛ in.). Seoul, National Folk Museum of Korea, 20959. Important Folklore Material No. 264. *Cheollik*, excavated clothing of Byeonsu (1447–1524), early 16th century. Silk, H: 120 cm (47¼ in.); w: 57 cm (22⁷⁄₁₆ in.); *hwajang* (length from center of back collar to the end of the sleeve): 111.5 cm (43 ⅞ in.). Seoul, National Folk Museum of Korea 국립민속박물관, 20951. Important Folklore Material No. 264

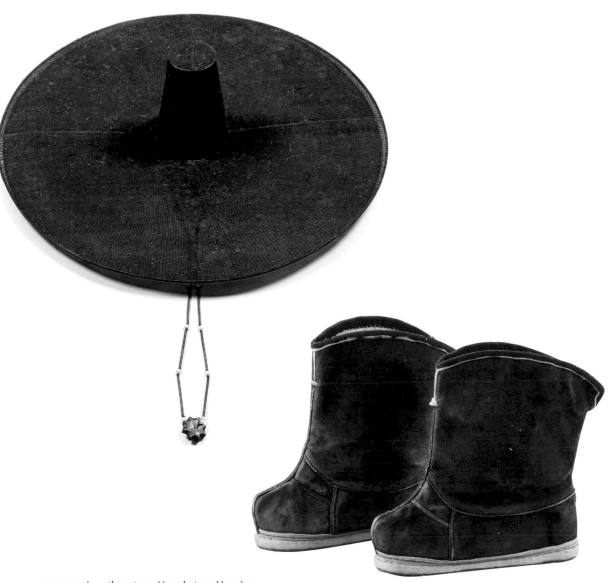

FIGURE 17 *Ip*, 19th century. Horsehair and bamboo, 19.5 × 72.3 cm (7 11/16 × 28 7/16 in.). Seoul, National Folk Museum of Korea 국립민속박물관, 29100

FIGURE 18 *Mokhwa*, Joseon dynasty. Leather, H: 7.2 cm (2 13/16 in.); W: 27.1 cm (10 11/16 in.); L: 26.7 cm (10½ in.). Seoul, National Folk Museum of Korea 국립민속박물관, 7291

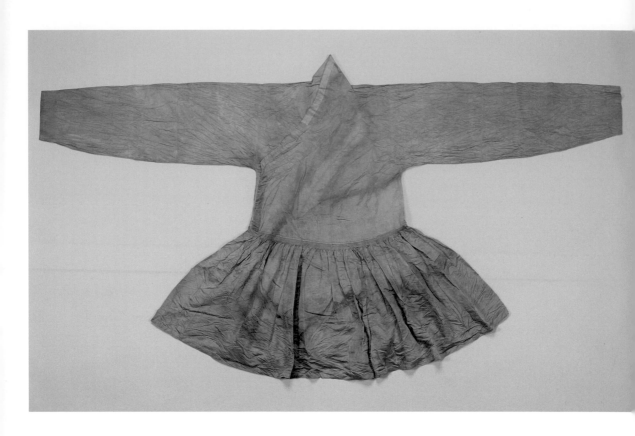

FIGURE 19 *Cheollik*, excavated clothing of Byeonsu (1447–1524), early 16th century. Silk, H: 119 cm (46⅞ in.); W: 61 cm (24 in.); *hwajang* (length from center of back collar to the end of the sleeve), 122 cm (48¹⁄₁₆ in.). Seoul, National Folk Museum of Korea 국립민속박물관, 20952. Important Folklore Material No. 264

The signature feature of the *cheollik* is that the bodice and skirt are separate pieces sewn together at the waist (fig. 19). The bodice is measured to fit, while the skirt is cut very wide and adjustable so that it gathers when cinched at the waist. The width of the bodice depended on a person's social rank: persons of good lineage did not exceed thirteen *pok* (a measurement of width) and commoners were limited to twelve *pok*. The width of the pleats varied in different eras according to the style. In Early Joseon there were many small pleats per centimeter; by the eighteenth century the pleats became wider. In the Early Joseon the small pleats formed at the top of the skirt fell as loose folds to the hem. In the drawing the relatively even, wavy folds seen under the overcoat appear to be an expression of the folds or pleats of the *cheollik*. The *dapho* and *cheollik* have a similar length, but in the drawing, the figure's outer garment is shorter than his inner garment. This seems to reflect the occasions during Joseon dynasty where the outermost garment would be folded at the waist when several garments were worn in layers.

Did Rubens Indeed Encounter This Man?

Rubens correctly depicted the inner clothing by showing the shorter outer coat, the multiple layers of clothing, the short-sleeved overcoat over the long-sleeved inner coat, and the fullness of the ample skirt. Although it is probable that the figure in Rubens's drawing wears a *dapho* and *cheollik* from Early Joseon, the drawn garments do not document Joseon-era styles. In addition to depicting the collar proportionally too wide, Rubens did not draw the sleeves of the *dapho*, the pants, and the headdress with precision. Thus it is appropriate to say that Rubens did not face a Joseon-era man. Instead he shows an imaginative interpretation of Korean costume, breathing vitality to exotic, never-before-seen attire.

NOTES

1 Yu Hui-gyeong, *Hanguk boksiksa yeongu* [Research into the history of Korean dress styles] (Seoul, 1980), p. 41.

2 Geum Jong-suk, "Joseon sidae cheollikui hyeongtae mit baneujilbeop yeongu" [Joseon dynasty *cheollik*: Forms and tailoring] (master's thesis, Daeguk University Graduate School, 2003), pp. 43–79.

3 The annals of King Sejong in *Joseon Wangjo Sillok* (*Annals of the Joseon Dynasty*) records that the king wore a *dapho* and *cheollik* in mourning on March 26, 1444.

4 National Folk Museum of Korea, *Obaengnyeon ui chimmuk, geurigo hwansaeng* [Five hundred years of silence, and then rebirth] (Seoul, 2000), p. 45.

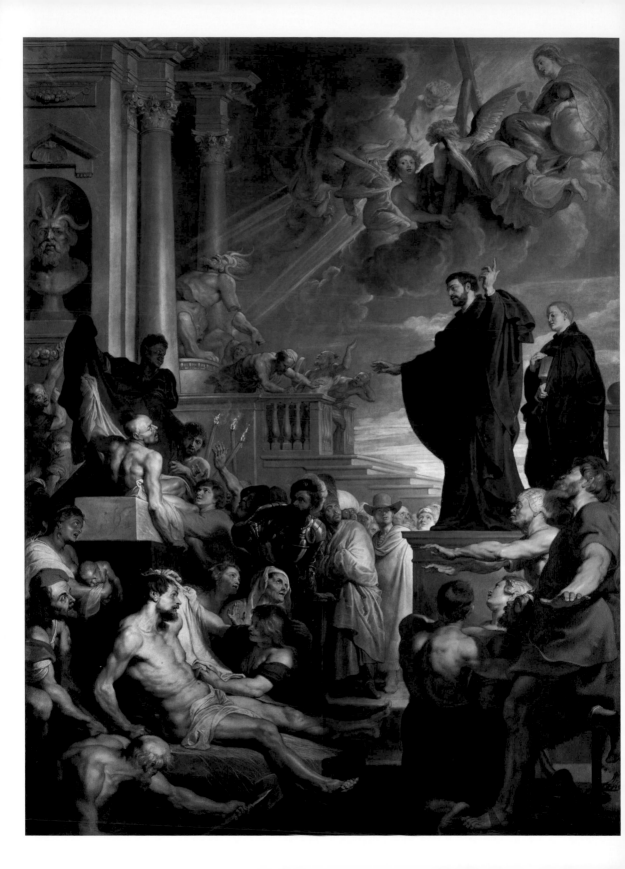

Implicit Understanding: Rubens and the Representation of the Jesuit Missions in Asia

Stephanie Schrader

To understand how Peter Paul Rubens came to depict his *Man in Korean Costume* (see fig. 1), one must begin with the Jesuit missionaries, the primary European eyewitnesses to and most prolific writers about Asian people, customs, and clothing.[1] From 1617 to 1618 the Jesuits in Antwerp commissioned Rubens and his assistants to commemorate their missionary work in China and Goa (in modern-day India). In fulfilling this Jesuit enterprise, Rubens and his studio made drawings and paintings of European missionaries wearing the opulent silk robes and tall, square headdresses of Chinese scholars. At this time Rubens also designed two monumental altarpieces celebrating the Jesuit leaders Ignatius Loyola (1491–1556) and Francis Xavier (1506–1552) for the newly built church of Saint Charles of Borromeo in Antwerp.[2] In the center of the altarpiece depicting Francis Xavier proselytizing in Goa (fig. 20) is a figure wearing attire similar to that shown in the Getty drawing. A nuanced reading of these paintings and drawings of missionaries demonstrates how the *Man in Korean Costume* relates to the Jesuits' appropriation of exotic costume to advertise their global mission at home and to assert their victory over "idolaters." By examining the work in this Jesuit context, one can speculate why Rubens made such a compelling depiction of Korean costume and how he used the Getty drawing to visualize the foreigner who may have worn it.

By the late sixteenth century, members of the militant Catholic religious order called the Society of Jesus, or Jesuits, were actively proselytizing in China, the largest and oldest civilization in Asia, with which Korea had a tributary relationship.

FIGURE 20 Peter Paul Rubens and Workshop, *The Miracles of St. Francis Xavier*, ca. 1617–1618. Oil on canvas, 535 × 395 cm (210⅝ in. × 155½ in.). Vienna, Kunsthistorisches Museum, Gemäldegalerie, 519

For all of their devotion and dedication, the Jesuits initially made little progress in China. By 1595, after ten or so years had yielded only around a hundred converts, the missionaries recognized that a better way to convert the "pagan" Chinese to Christianity would be to infiltrate the Ming dynasty's government structure.[3] In the face of naysayers who warned that trying to convert the Chinese was a "sheer waste of time," the Jesuits persevered.[4] They came to realize true progress depended upon their knowledge of Mandarin. Within a short time, brilliant Jesuits such as Matteo Ricci (1552–1610) and Nicolas Trigault (1577–1628) mastered both written and spoken Mandarin, distinguishing themselves as learned foreigners who could discuss complex subjects such as mathematics, astronomy, clockwork, and cartography.[5] They also realized that fitting in extended to dress. In keeping with the promotion of their cultivated image, the Jesuits in China refashioned their clothing as that of the Confucian scholars, or *literati*.[6] In their effort to, in the words of Matteo Ricci, "proceed confidently as though we were in fact men of China," the Jesuits donned the long silk robes and the tall four-corner hats worn by Confucian scholars as well as let their hair and beards grow long.[7] According to Michele Ruggieri, Ricci's associate in China, this new policy of enculturation better positioned them to "win China for Christ."[8]

The Jesuit missionaries' appropriation of the Chinese *literati* dress is recorded in four drawings that have long been associated with Rubens and his *Man in Korean Costume*.[9] Three of the four depict the important Jesuit leader of the Chinese mission, Nicolas Trigault (fig. 21), whose name appears in an inscription on the bottom left of a sheet now in the Metropolitan Museum of Art: *Tricau . . . Soc.*

FIGURE 21 Peter Paul Rubens, *Portrait of Nicolas Trigault in Chinese Costume,* 1617. Black chalk, touches of red chalk in the face, blue-green pastel in the collar facings and bands of the sleeves and along the bottom of the robe, pen and brown ink, traces of heightening with white chalk; profile sketch in pen and brown ink, 44.6 × 24.8 cm (17 9/16 × 9 3/4 in.). Purchase, Carl Selden Trust, several members of the Chairman's Council, Gail and Parker Gilbert, and Lila Acheson Wallace Gifts, 1999, New York, Metropolitan Museum of Art, 1999.222

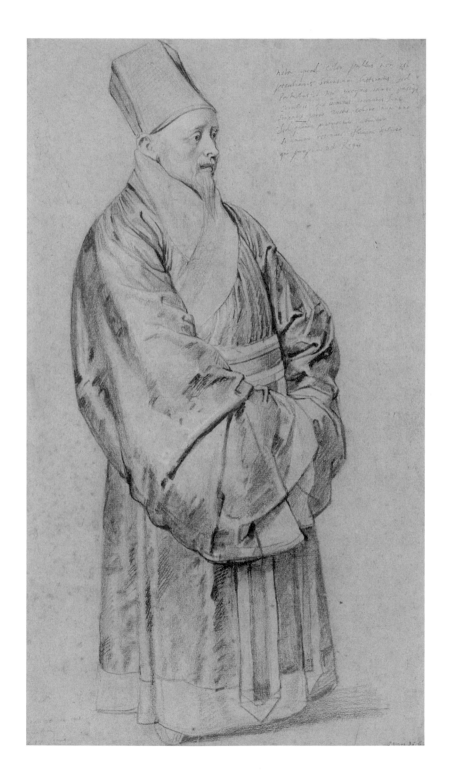

Jesu/delineatum/die 17 Januaris.[10] This sheet is primarily executed in black chalk with touches of red chalk in the face, and blue-green pastel in the trim of the collar, sleeves, and bottom of the robe. It is on similar paper stock to that of the Getty drawing and with approximately the same dimensions.

Although scholars now universally accept the Metropolitan drawing as being by the hand of Rubens, they were previously ambivalent about his authorship.[11] An annotation in the lower right-hand corner, *A. van Dyck fecit*, asserts that Anthony van Dyck (1599–1641), Rubens's premier assistant from 1616 to 1620, made it.[12] According to Anne-Marie Logan and Michiel Plomp, however, this erroneous attribution to Van Dyck came after Hendrik van Eyl Sluyter sold the drawing as an original by Rubens in 1814.[13] To further complicate matters, there is an almost identical version of the Metropolitan portrait of Trigault in the Nationalmuseum in Stockholm (fig. 22). Reversing previous scholarship, Logan has suggested that the Metropolitan drawing is the primary sheet that the Stockholm version paraphrases. She rightfully notes that Stockholm's Trigault is decidedly less carefully drawn, with awkward passages reflective of hesitation as seen in the lower end of the sash at the right and in the rendering of the hem.[14] Furthermore, the modeling of the fabric and the headdress in the Stockholm drawing is somewhat less convincing; the light and dark juxtaposition reads more like a flat pattern. These less confidently executed details suggest that the young Anthony van Dyck, Rubens's only named assistant at this time, copied the Metropolitan drawing while he was working in the master's studio.[15]

The two versions of Trigault certainly attest to the striking figure the Jesuit missionary must have cut, wearing his tall, square hat and floor-length silk robe with wide sleeves. While Rubens emphasized the dynamic flow of fabric in the *Man in Korean Costume* (see fig. 1), he articulated the voluminous folds of the exotic

FIGURE 22 Peter Paul Rubens or Anthony van Dyck(?) (Flemish, 1599–1641), *Portrait of Nicolas Trigault in Chinese Costume,* ca. 1617. Black chalk, heightened with white chalk, touches of yellowish ocher and red chalk in the face and turquoise and blue-green chalk in the collar, on gray paper, 41 × 25.4 cm (16⅛ × 10 in.). Stockholm, Nationalmuseum, 1968/1863

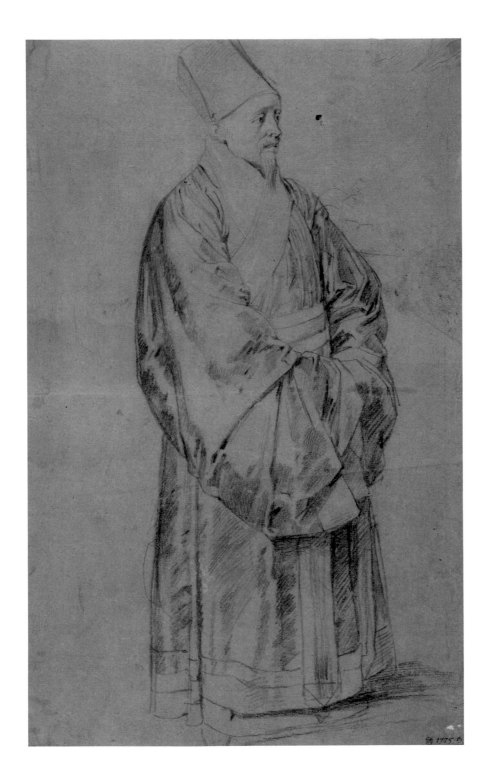

attire as well as the shimmer and sheen of the opulent silk fabric in the Metropolitan sheet (see fig. 21) in a more matter-of-fact manner. This sense of reportage conforms to the drawing's function—the documentation of the *literati* costume donned by the Jesuits in China. The long Latin inscription in Rubens's hand at the upper right records this factual information about the costume.[16] In translation, it reads: "Note that the dark color is not peculiar to Chinese scholars but to the Fathers of the Society of Jesus, except for the blue facings, which are common to all. The Chinese, furthermore, do not use one color only in their clothing, but any color they like, except yellow, which is reserved for the king [emperor]."[17] As Logan observed, the costume worn by Trigault in the Metropolitan drawing reflects the advice given by Ricci. The latter recommended that the Jesuit fathers wear a dark purple silk robe with long, wide sleeves with a border half a palm in width in bright blue silk at the sleeves, lapel, and hem.[18] The inscription also states that, however sumptuous, Chinese costumes of the Jesuits must not offend the emperor by assuming his exclusive imperial color of yellow. The mention of the robe's dark color as peculiar to the Jesuit fathers further reflects their efforts to fashion a variant of the *literati* costume that was specific to their order.

In addition to the Metropolitan drawing, the same slight man with pointed goatee dressed in Chinese garb appears in a life-size painting (fig. 23) now in Musée de la Chartreuse, Douai.[19] Conceived by Rubens and executed by his studio, it was made for the Jesuit College in Douai. The Latin inscription on a tablet depicted at the bottom left of the painting not only identifies the sitter as Trigault but dates the work to 1617.[20] The painting, like the drawings, documents the European publicity tour that the Douai-born Trigault conducted from 1613 to 1618,[21] when he returned to Europe seeking money and priests to support the Jesuit mission in China.[22] To convince wealthy princes and prelates to open their coffers and to persuade young men to make the perilous commitment to conduct missionary work in China, it was crucial that he portrayed the Chinese mission as a magnificent, successful enterprise. As Trigault, dressed in lavish, Chinese silks, traveled

FIGURE 23 Workshop of Peter Paul Rubens, *Nicolas Trigault*, ca. 1616. Oil on canvas, 220 × 136 cm (86⅝ × 53⁹⁄₁₆ in.). Douai, France, Musée de la Chartreuse, 27

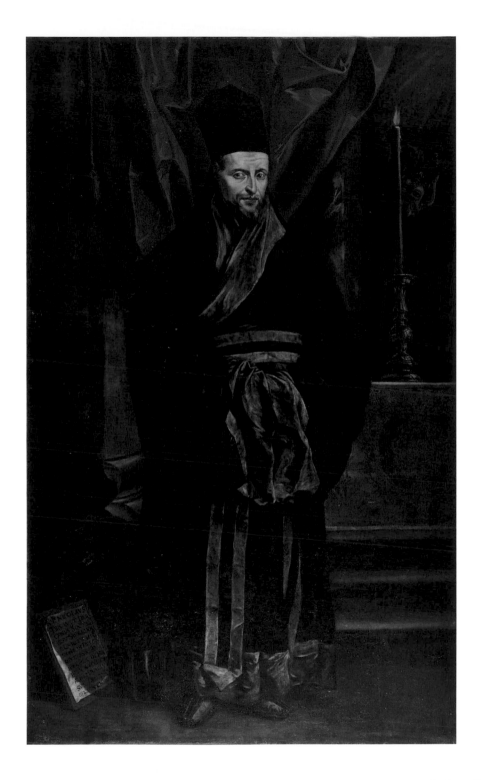

throughout Italy, Germany, the Netherlands, Spain, and Portugal, he reported of "steady evangelical progress and the prospect of millions of souls to be saved."[23] In the words of Liam Brockey, "Trigault gave human form to the reports of missionary glory."[24]

The missionary's publicity tour began in Rome, where he sought clarification from the Holy See about administrative procedures in China. According to George Dunne's characterization, two of the requests for policy directives were "radical in nature and of far-reaching importance."[25] One was that priests in China be permitted to keep the head covered while celebrating the mass because, counter to the European custom, the Chinese considered it disrespectful for a man to remove his hat; the other was that the priests could perform the mass in Chinese instead of the customary Latin because the Chinese people could not distinguish between the consonants of the Latin alphabet.[26] The painted portrait of Trigault conveys the exotic splendor the missionary must have conveyed to the pope with his opulent, dark silk Chinese robes with blue trim and a tall, square hat. At the same time, the portrait allays fears that the missionaries in China were becoming "too Chinese."[27] To address this concern, Trigault is shown standing aside the steps of an altar—the locus of the performance of the mass. A red curtain is dramatically pulled back behind him revealing the corner of an altarpiece and a lighted candle on the altar. In proximity to these holy furnishings and garbed in Chinese robes and headdress, Trigault appears to claim possession of Chinese costume for the glory of the Catholic faith. He is also shown demonstrating the ardent belief of the Jesuit missionaries in China that accommodating to the Chinese was the only way "to divulge and teach the holy doctrine."[28] On January 15, 1615, Pope Paul V granted the Jesuit missionaries in China permission to keep their Chinese headdresses on while performing the mass.[29] Interestingly, the pope remained silent about adopting Chinese as the liturgical language. According to Dunne, the Jesuits in Japan were vehemently opposed to the idea of using local language to perform the mass, and they may have dissuaded the pope against Trigault's request.[30]

The painting of Trigault finds visual parallels in the title page illustrating the memoirs of the founder of the Chinese mission, Matteo Ricci (fig. 24). On his voyage from China to Europe, Trigault translated Ricci's manuscript from Italian

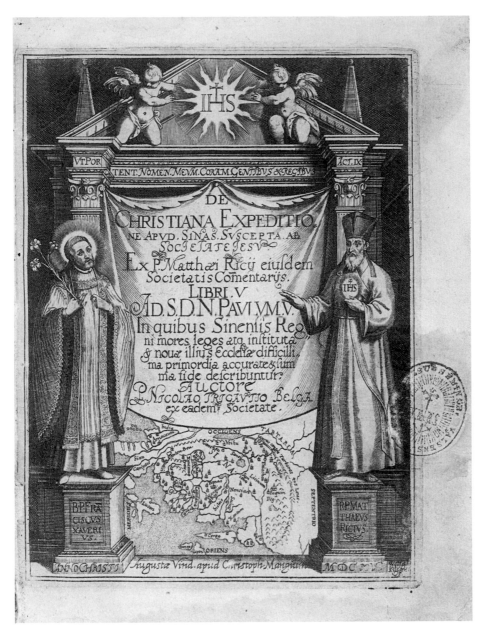

Wolfgang Kilian (German, 1581–1662), *Title Page with Francis Xavier and Matteo Ricci,* 1615. Engraving, 17 × 12.7 cm (6¾ × 5 in.). From Matteo Ricci, *De Christiana Expeditione apud Sinas Suscepta ab Societate Jesu,* trans. Nicolas Trigault (Augsburg, 1615). Los Angeles, Getty Research Institute, 2718-036

into Latin and arranged to have it published in Augsburg in 1615. Describing Chinese customs and culture from a European's point of view as well as providing a synopsis of the Jesuit mission in China from 1583 to 1610, *De Christiana Expeditione apud Sinas* (Christian expedition to China) served as an ideal promotional text for Trigault during his publicity tour. The book sold widely and was quickly republished in French, German, and Italian.[31] At the left of the title page is Francis Xavier, the founder of the Jesuit missions in Asia, who died on the island of Shangchuan awaiting permission to enter the Chinese mainland. At right is Ricci, Xavier's brilliant successor in China. Standing on pedestals, the two priests act, compositionally and symbolically, as the pillars upon which the Jesuit mission in Asia was built. A map primarily featuring China displayed underneath Xavier and Ricci points to their achievements in proselytizing in Asia. Illustrating Korea's close proximity to China, the map also includes a nearby peninsula depicted in a rudimentary manner and identified as "Corea." The naming of Korea may also refer to the vassal relationship of Korea to China and by implication suggest the Jesuits' aspirations to gain access there. Ricci already began to explore this possibility in 1601 as evidenced from the fact that Yi Su-gwang, a Korean envoy in Beijing, returned to Korea from China with Ricci's catechism, *A True Account of the Master of Heaven*.[32] In contrast to Xavier, who wears a more traditional cassock, Ricci dons the costume of a Chinese scholar. The portrayal of Ricci and Xavier wearing different clothing reflects the shift in Jesuit policy "to become Chinese in order to win China for Christ" as described by Ruggieri.[33] To publicize the appropriation of Chinese costume and by inference Chinese souls in the name of Catholicism, the Jesuit monogram "IHS" (*Iesus Hominum Salvator*, or "Jesus Savior of Men") is emblazoned on Ricci's Chinese robes.

A drawing in the Morgan Library depicting a tall, curly-bearded European man (fig. 25) documents a Jesuit other than Trigault donning the Chinese robes and a tall, square-shaped headdress. Unlike the Getty and Metropolitan drawings,

FIGURE 25 Peter Paul Rubens or Anthony van Dyck(?), *Jesuit Missionary in Chinese Robes*, 1617. Black chalk and some green chalk, 42.4 × 24.4 cm (16 11/16 × 9 5/8 in.). New York, Morgan Library and Museum, Acq. 3, 179

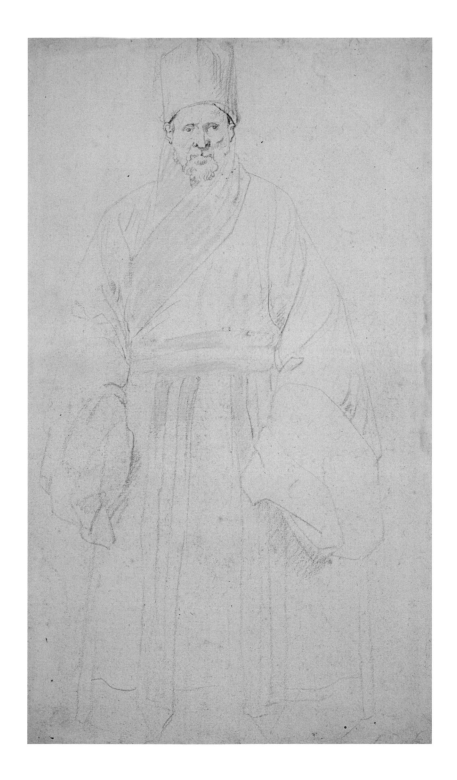

the Morgan work is cursorily executed in black chalk. It is annotated in black chalk, at the bottom right, with the name *A. Dyck*, despite the fact that the attribution to Rubens has usually, if not universally, been accepted since Clare Stuart Wortley published the group of drawings in 1934.[34] Independently of each other, Anne-Marie Logan and Stijn Alsteens now believe that the Morgan drawing is by Anthony van Dyck. Indeed, the Morgan drawing's strong contour lines and slight use of shading seem more characteristic of the early drawings Van Dyck made when he was working under Rubens.[35] Even while drawn with thick lines, the small face is secondary to the depiction of *literati* costume. The frontal pose and close cropping of the figure call further attention to the voluminous silk robes. Indeed, the European man appears subsumed by his identity as a missionary in China.

Felice Stampfle tentatively suggested that the Morgan sheet depicts Johann Terrenz Schreck (Latinized to *Terrentius*), a noted scientist and friend of Galileo Galilei who was ordained a Jesuit in 1611.[36] Trigault recruited Schreck for the Chinese mission in 1616 and the two men traveled to Antwerp and Brussels the following year. There are no known portraits of Schreck that would substantiate this identification, but given the important role he played as Trigault's companion on the publicity tour—acquiring books, mechanical equipment, and scientific instruments for the Chinese mission—it is plausible the new recruit would have had his portrait executed by Rubens's workshop as well.[37]

The Morgan's depiction of a Jesuit recruit as a member of the *literati* implies that Trigault brought multiple sets of Chinese robes and headdresses back from China. According to Brockey, to whet collectors' insatiable appetite for *exotica* and to pique curiosity about the Chinese mission, Trigault transported a considerable quantity of "Chinese *objets d'art*" and "samples of books containing the ancient wisdom of the Confucian tradition."[38] Part of this cache of collectibles would have logically included expensive Chinese costumes. This importation of luxurious silk clothing in quantity would have borne testimony to the Jesuits' business acumen overseas. Beginning in 1583 the Jesuit missionaries received permission to partner with Portuguese merchants in the trade of Chinese silk, netting an annual profit of about sixteen hundred ducats.[39] Worn by the many new recruits before they left for China, these extra costumes would have further proclaimed the glorious success of the Chinese mission to European Catholics.[40]

The wearing of exotic attire to aggrandize the missionaries' proselytizing adventures in Asia continued even after Trigault and his twenty-one recruits set sail for China on April 16, 1618.[41] Wortley was the first to associate the drawings of missionaries wearing Chinese costume and the Getty figure donning Korean robes and headdress with the Jesuit festival held in Rubens's native city of Antwerp.[42] From July 23 to 24, 1622, the Jesuits celebrated the canonization of Saints Ignatius Loyola and Francis Xavier. A Latin account of the events appeared in a pamphlet printed by the Plantin Press in 1622.[43] It reports that on the second day of the celebration, students of the Jesuit College, acting as catechumens, walked six by six in procession wearing costumes native to Tamil Nadu, Paravar, Malacca, Japan, Malaysia, and China.[44] Wearing the exotic costumes of the countries in which the Jesuits had spread the word of Christ, the celebrants proclaimed Jesuit victory over the "idolaters." If the missionary triumph were not highly touted enough by the appropriation of exotic costume, it was further driven home by the rhetorical speeches extolling Saint Francis Xavier, the founder of the Jesuit missions in Asia. The grand finale reinforced the importance of the Chinese mission with thirty-six students marching in the procession clad in floor-length cotton robes modeled after Chinese *literati* costume and tall, square-shaped hats.[45] Accompanying them was a student dressed as a guardian angel, who was extolled as the "most beautiful" of these due to the fact that he was from the Chinese culture of "affluence and cultivated customs that exceeded all the others."[46] Wearing the garb of the Chinese *literati* with the guardian angel at their side, the Jesuits implicitly claimed China for Christendom with all of its magnificence and ancient learning.

While comparable in its Asian sartorial splendor, the costume in the Getty drawing (see fig. 1) differs in specific respects from Chinese costumes worn by European Jesuits described in the aforementioned procession and images. Compared to the depictions of Trigault and the other recruited missionary, the figure in the Getty sheet wears a shorter robe with narrower sleeves as well as a transparent horsehair headdress instead of a square Confucian hat. Although there is a broad band of silk trim depicted at the neck, there is no suggestion of this greenish-blue trim at the hem or edges of the sleeves as seen in the portrayal of Chinese costume. Closer examination of the costume details in the Getty drawing reveals silk robes characterized by numerous folds, which are especially visible in

the underskirt. In the opinion of Korean costume experts, these folds are created by small gatherings of pleats at the waist and are characteristic of a *cheollik* (see fig. 19).[47] Furthermore, Korean costume historians also believe that the square-shaped headdress depicted by Rubens is suggestive of those woven out of horse-hair called a *banggeon* (see fig. 11).[48]

To account for the discrepancy in costume, scholars have posited that the Getty sheet represents a Korean Jesuit whom Trigault brought with him from China.[49] This seems unlikely for the simple reason that the only recorded Korean Jesuit living in China in the early 1600s was a certain Vincent Caun, who was sent to Beijing after Trigault left China for Europe.[50] Caun's known presence in China raises an important issue, however. To date, no documentation has been found of any Asian Jesuit accompanying Trigault to Europe.[51] Surely, if a recent Korean convert from the little-known kingdom of Korea had traveled with Trigault on a five-year European publicity tour, his novel presence would have been worth mentioning—especially by the Jesuits themselves. This is precisely what happened when the Jesuit Alessandro Valignano sent an embassy of four Japanese converts on a publicity tour throughout Europe from 1584 to 1590, as the many pamphlets and poems (forty-nine in 1585 alone) describing the Japanese converts attest.[52]

The tantalizing possibility of Trigault having contact with Korea would have likely come in the form of material goods. Korean diplomats came to China three times a year on average to pay tribute, with the suzerain–vassal relationship between China and Korea resulting in an extensive exchange of goods between nations.[53] A Korean mission attracted various Chinese merchants eager to acquire Korean products, and the subordinates of Korean ambassadors also worked as sales and purchasing agents for merchants back home who specialized in silks and other luxury goods.[54] Korean silk was part of the tributary goods given to the Chinese, and, in exchange, Korean ambassadors received Chinese silk and satin clothing.[55] The trade between the Chinese and Koreans took place in the capital of Beijing, a city where the Jesuits conducted their missionary work.[56] Thus it is entirely possible that Trigault acquired Korean costume in Beijing during his visit there in 1611.

As there is no documentation of a Korean Jesuit in Antwerp, it seems worthwhile to posit that the talented artist based his drawing on imported Korean silk

robes and a horsehair headdress. Rubens was in contact with the Jesuit mission-
aries to execute their portraits in Antwerp in 1617. During this time he clearly had
access to their cache of exotic costumes—a collection that may very well have
included Korean robes and headdresses. It stands to reason that Trigault or one
of his recruits could have modeled Korean costume for Rubens and spurred the
artist's fascination with the never-before-seen attire.

Indeed, the Getty drawing signals an artist captivated with foreign costume:
every crease and fold, every shimmer and sheen was considered worthy of atten-
tion. Rubens was so concerned with his portrayal of the cascade of folds that the
legs and feet were secondary in importance (fig. 26). As the left leg stops short of
the bottom of the page, the partial depiction of the legs does not seem to indicate
a later cropping of the sheet. The strange truncated calves instead register the art-
ist's lack of knowledge about what was worn underneath the voluminous robes.

FIGURE 26 Peter Paul Rubens, *Man in Korean
Costume* (detail, fig. 1), showing the legs

Rubens presented two options: on the right he drew loose leggings that echo the vortex of swirling silk robes above; on the left he offered a completely bare calf.

This fascination with one aspect of the exotic costume at the expense of another also occurs in the depiction of the headdress (see fig. 5). Rubens was clearly captivated by a porous headdress that allowed light and air to pass through it, but not as interested in its structure. He did not employ cross-hatching to suggest that the headdress was made of woven horsehair. Instead he used delicate, parallel hatching to heighten the sense of transparency. Rubens also did not depict what was typically found underneath transparent headdresses in Korea: the long hair wound up into a topknot, as evidenced in the portrait of the Korean scholar Yi Gwang-sa by Shin Han-pyeong (see fig. 37).[57] Instead the Flemish artist introduced wisps of short hair protruding from the headdress and a conical-shaped inner cap, creating his own covering of the head.

Entirely removed from the culture to which the novel costume and headdress belonged, Rubens fashioned the foreign attire to his liking. In this vein, his *Man in Korean Costume* presents the artist's idea of an Asian foreigner, not a portrait of one. In early-seventeenth-century Europe, distinctions between the Chinese and Korean people were virtually unknown. Thus it is not surprising that Rubens's figure has only generic Asian facial features (see fig. 5). Commonplace in Rubens's time, stereotypes about Asian physiognomy—high cheekbones, flat noses, heavily arched eyebrows, and deeply set elliptical eyes—were found in written descriptions of Asia, such as in Ricci's memoirs of China translated by Rubens's patron Trigault. They also appeared in illustrations of Asians, such as those of the Chinese found in Johann Theodor de Bry's *India Orientalis Pars II* (Frankfurt, 1599; fig. 27) that Rubens himself owned.[58] Using subtle touches of red chalk to the cheeks, ears, and lips, together with a direct, confrontational gaze, Rubens animated the staid stereotypes of Asian facial features to make his figure appear more lifelike.

Did Rubens's pure fascination with foreign costume alone motivate the artist to make his *Man in Korean Costume* so compelling? An examination of the Getty figure's reappearance in his *Miracles of St. Francis Xavier* (see fig. 20) facilitates a partial answer to this question. Executed for the high altar of Saint Charles of Borromeo church in Antwerp, this monumental altarpiece, with its life-size figures,

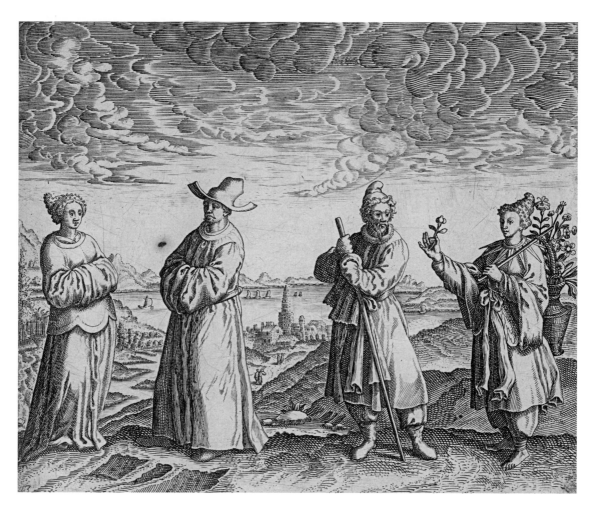

FIGURE 27 Johann Theodor de Bry (German, 1561–1623), *Chinese clothing*, pl. 23, from *India Orientalis Pars II*, 1599. Engraving, 35 × 19.7 cm (13¾ × 7¾ in.). San Marino, California, The Huntington Library, 122166, pt. 2

portrays a synthesis of miracles performed by the Jesuit missionary in Goa.[59] According to Dauril Alden, by 1530 Goa was the capital of the "so-called Portuguese State of India, which extended from the Swahili coast of Mozambique to South China." It was also "the principal port as well as the administrative and ecclesiastical center for the Portuguese, Eastern Empire."[60] In 1541 the first Jesuit, Francis Xavier, arrived in Goa, where he proselytized among its mixed population of Brahmans, other Indian natives, Portuguese colonists, Chinese, Malays, Arabs, Abyssinians, and natives of Mozambique.[61]

Rubens portrayed Xavier, with his acolyte, standing on an elevated plinth while his miraculous deeds unfold simultaneously beneath him. In depicting these miracles, Rubens likely consulted Horatius Tursellinus's *De Vita Francisci Xaverii* (The life of Francis Xavier) (Antwerp, 1596), which recounted how the Jesuit resuscitated a dead infant, cured a crippled blind man, and exorcized a man possessed of demons.[62] In the painting, Xavier raises his left hand pointing to the source of his divine power—an allegorical figure of the Catholic faith holding a chalice and carried aloft by angels in the clouds above. Amid the gaping mouths, poignant tears, and outstretched arms are also less dramatic conversions. In the center of the composition stands a group of "heathen priests" who, according to Tursellinus, debated with Xavier and were convinced by his arguments.[63] Among these pagan priests is a figure (fig. 28) that resembles the one in the Getty drawing. Rubens adapted his solitary subject from the drawing to fit into a complex religious narrative. No longer shown standing with a ship in the background, in the painting he is crowded among the other "heathens" who are awakened by the "true faith."

When Rubens began his *Miracles of St. Francis Xavier*, the Jesuit missionary had not yet been canonized or even beatified.[64] It is highly likely that the Jesuits commissioned this grand altarpiece with its drama and incident as a propaganda device to popularize Xavier and his miracles, thereby fast-tracking the missionary's canonization.[65] Accordingly, Rubens's Jesuit patrons appear to have carefully supervised the artist's depiction of the miracles. Rubens first presented the Jesuits with the smaller oil sketch *modello* (fig. 29) illustrating his compositional ideas. Evidently the Jesuits asked Rubens to make a consequential change in the final painting. The *modello* (fig. 30) shows pagan priests wearing Turkish turbans and

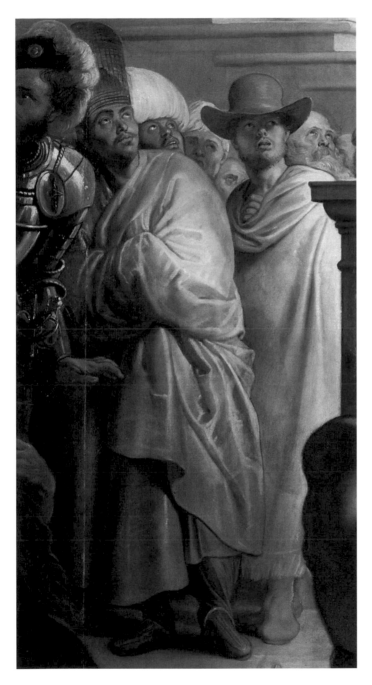

FIGURE 28 Peter Paul Rubens and Workshop, *The
Miracles of St. Francis Xavier* (detail, fig. 20),
showing pagan priests

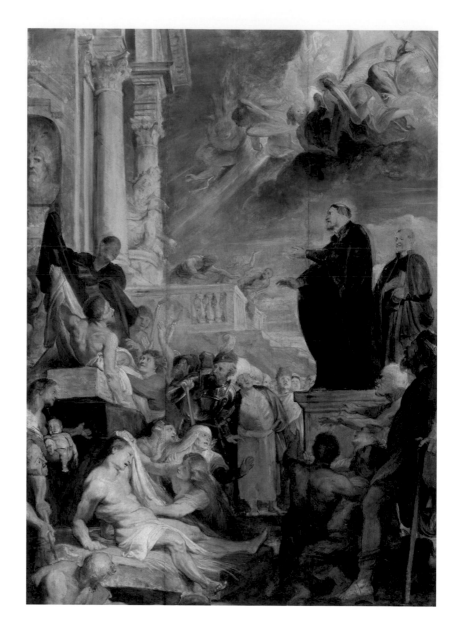

FIGURE 29 Peter Paul Rubens, *Modello* of *The Miracles of St. Francis Xavier,* ca. 1617. Oil on canvas, 104.3 × 72.4 cm (41¹⁄₁₆ × 28½ in.). Vienna, Kunsthistorisches Museum, Gemäldegalerie, 528

FIGURE 30 Peter Paul Rubens, *Modello* of *The Miracles of St. Francis Xavier* (detail, fig. 29), showing pagan priests

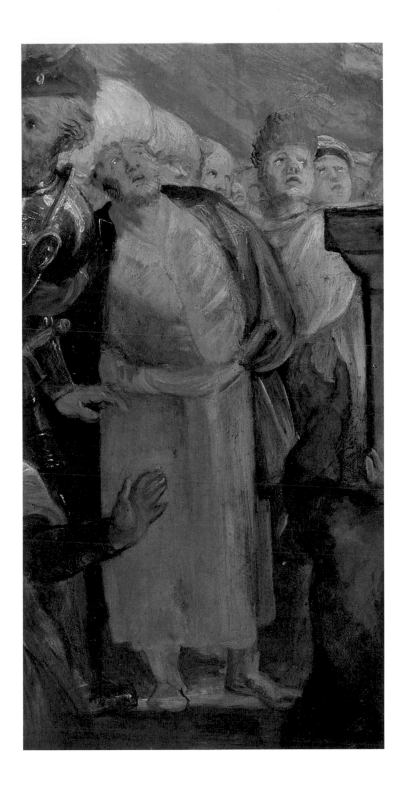

caftans. It appears the Jesuits in Antwerp wanted Rubens to make a more specific reference to Goa by depicting a variety of exotic types they thought could actually be found there. Rubens thus eliminated figures in Turkish garb, substituting in their place pagan priests wearing an array of exotic costumes, including one wearing a transparent horsehair headdress and a golden yellow silk robe that are modeled after those in the Getty drawing.

Rubens's insertion of the figure from the Getty drawing into a Jesuit missionary narrative concerning Goa underscores how his patrons valued the costume for its generic exotic quality, not its specific Korean identity.[66] In *The Miracles of St. Francis Xavier* (see fig. 20), the depiction of exotic costume establishes a hierarchy of Catholicism over paganism. Rubens portrayed Xavier dressed in a somber black habit. In contrast, he showed the pagan priests dressed in brightly colored robes and exotic headdresses. The pagan priest in Korean attire stands beside an African priest in a turban and another priest in light purple robes. The man in light purple might be meant to represent a Chinese man, since his bright red headdress resembles one worn by a Chinese figure in the earlier mentioned *India Orientalis Pars II* by de Bry (see fig. 27). Compared to Xavier and his classicizing drapery that conforms to a purposeful stance and dynamic, outward gestures, the pagan priests are arrested in their movement with their vibrant, sleeveless robes enclosing them. Rubens depicts them as awestruck and powerless while Xavier commands the divine light to strike down the idol in the pagan temple above them, signaling the literal collapse of their world order.

Placed in the great Jesuit church in Antwerp before Xavier was canonized, this huge altarpiece was to inculcate mass belief in miracles the Jesuit leader performed in Goa. Given its propagandistic mission, the painting had to be convincing. It was Rubens's task to create a believable portrayal of Francis Xavier and his remarkable ability to persuade "idolaters" of the "true" faith. To this end, Rubens used exotic clothing to demarcate primitive paganism and represent the fervent belief that he and the Jesuits shared, in the superiority of the missionary endeavors of the Catholic Church.

In the Getty drawing (see fig. 1) one detects Rubens's initial encounter with foreign costume and senses the artist's fascination and effort to describe the unfamiliar. There is no room for this mode of comprehension in the propagandistic

altarpiece in which the man wearing Korean costume reappears. In the painting, the exotic costume becomes a way to identify a foreign convert. To this end, Rubens altered the pose and details of his original figure. He is now shown in profile, gazing up in awe at Xavier and bearing witness to the charismatic missionary's miraculous power to convert. Among the crowd of pagans, the Getty figure gains legs and feet as well as leggings and boots. The transparent headdress gets structural support and appears woven. The face becomes more individualized with a moustache and goatee. Insofar as these features are different in the painting, the Getty drawing is not a typical preparatory study for *The Miracles of St. Francis Xavier*.[67] Instead it functions as an independent study that inspired the depiction of the pagan priest in the altarpiece.

Using the evidence at hand, one can hypothesize a new interpretation of Rubens's *Man in Korean Costume*. While Rubens was occupied commemorating the Jesuit missions in China and Goa, he took a pause to consider the Asian "idolaters" on the other side of the globe: Who were these people the Jesuits were trying to conquer for Christ and what did they look like? How might their exotic attire differ from what the Jesuit missionaries wore themselves? This imaginative turn seems to have been inspired by a firsthand encounter with a never-before-seen Korean costume and headdress. In addition to being the first depiction of Korean costume in the West, the Getty drawing demonstrates Peter Paul Rubens's extraordinary ability to create a tantalizingly credible portrayal of an exotic foreigner.

NOTES

1 Marcia Reed, "Bernard Picart on China: 'Curious' Discourses and Images Taken Principally from Jesuit Sources," in *Bernard Picart and the First Global Vision of Religion*, edited by Lynn Hunt, Margaret Jacob, and Wijnand Mijnhardt (Los Angeles, 2010), p. 216.

2 The date for the paintings derives from an entry dated April 13, 1617, in the account book of the Jesuit church in Antwerp that records Rubens was owed three thousand guilders. This amount refers to the contract Rubens signed on March 29, 1620, with Father Jacobus Tirinus for the delivery of "two large paintings of our Holy Fathers Ignatius and Xavier, already executed by the said Sr. Rubens for the choir of the aforesaid new church." For a discussion of these documents, see Hans Vliege, *Saints*, vol. 2, *Corpus Rubenianum Ludwig Burchard*, pt. 8 (Brussels, 1968), p. 28. For a recent discussion of the iconographic program of the church, see Anna C. Knaap, "Meditation, Ministry, and Visual Rhetoric in Peter Paul Rubens's Program for the Jesuit Church in Antwerp," in *The Jesuits II: Cultures, Sciences, and the Arts 1540–1773*, edited by John W. O'Malley et al. (Toronto and Buffalo, 2006), pp. 157–81; and Willibald Sauerländer, *Der Katholische Rubens* (Munich, 2011), pp. 82–101.

3 Jonathan Spence, *The Memory Palace of Matteo Ricci* (New York, 1983), pp. 178–79.

4 This is a paraphrase of the Jesuit leader in China, Matteo Ricci, who claimed, "Some few who had the experience with Chinese people said that any attempt to win them over was a sheer waste of time, like trying to whiten an Ethiopian." See Louis J. Gallagher, trans., *China in the 16th Century: The Journals of Matthew Ricci 1583–1610* (New York, 1953), p. 131; and Pasquale D'Elia, *Fonti Ricciane: Documenti orginali concernenti Matteo Ricci e la storia delle prime relazioni tra l'Euorpa e la Cina, 1579–1615,* vol. 1 (Rome, 1942), pp. 145–46n204.

5 Anne-Marie Logan and Liam Brockey, "Nicolas Trigault, SJ: A Portrait by Peter Paul Rubens. Part I. A Note on the Drawing; and Part II. The Death and 'Disappearance' of Nicolas Trigault," *Metropolitan Museum of Art Bulletin* 38 (2003), pp. 163–64; and Spence, *Memory Palace* (note 3), p. 32.

6 Matteo Ricci, the renowned founder of the Jesuit mission in China, was finally allowed to reside in mainland China in 1583. See Dauril Alden, *The Making of an Enterprise: The Society of Jesus in Portugal, Its Empire, and Beyond 1540–1750* (Stanford, 1996), p. 69; and Jonathan Spence, *The Chan's Great Continent: China in Western Minds* (New York and London, 1998), p. 32.

7 Willard J. Peterson, "What to Wear? Observation and Participation by Jesuit Missionaries in Ming Society," in *Implicit Understandings: Observing, Reporting, and Reflecting on the Encounters between Europeans and Other Peoples in the Early Modern Era,* edited by Stuart B. Schwarz (Cambridge, 1994), p. 416. Peterson provides a thorough analysis of the Jesuits' policy of enculturation in China. He quotes the Jesuit Matteo Ricci in this passage. See D'Elia, *Fonti Ricciane* (note 4), p. 378n491.

8 See Peterson (note 7), p. 409. Peterson quotes the Jesuit Michele Ruggieri in this passage. See also P. Pietro Tacchi Venturi, *Opera storiche del P. Matteo Ricci,* vol. 2 (Macerata, Italy, 1913), p. 416.

9 For a discussion of all five of these drawings as a group, see Clare Stuart Wortley, "Rubens's Drawings of Chinese Costume," *Old Master Drawings* 9 (1934), pp. 40–47; Julius Held, *Rubens: Selected Drawings* (Mt. Kisco, N.Y. 1986), pp. 119–20; George Goldner with Lee Hendrix and Gloria Williams, *European Drawings 1: Catalogue of the Collections* (Malibu, 1988), pp. 210–12; Anne-Marie Logan with Michiel Plomp, *Peter Paul Rubens: The Drawings* (New York, 2005), pp. 219–25; and Logan and Brockey, "Nicolas Trigault, SJ" (note 5), pp. 157–68. Except for the drawing that is now in a private collection and untraceable, these drawings are catalogued in this essay. The untraceable drawing is drawn in black chalk with touches of red chalk on the face and measures 13¾ × 8⅞ in. It depicts the same European man with a pointy beard wearing Chinese *literati* costume. It was, like the Getty sheet, reproduced by Captain William Baillie. A fantastic impression of this reproductive print is in the collection of the British Museum, London, inv. nr. 1891,0414.1013.

10 Logan translates this inscription as "Tricau[lt] [possibly Tricaucio, the Latinate version of his name], Society of Jesus, drawn on January 17." See Logan and Brockey, "Nicolas Trigault, SJ" (note 5), p. 157. For the earliest attribution to Trigault, see Henri Bernard, "Un portrait de Nicolas Trigault dessiné par Rubens?" *Archivum Historicum Societatis Jesu* 22 (1953), pp. 308–13.

11 For a summary of these attributions, see Logan, *Peter Paul Rubens* (note 9), pp. 222–25; and Hans Vliege, *Rubens Portraits of Identified Sitters Painted in Antwerp,* vol. 2, *Corpus Rubenianum Ludwig Burchard,* pt. 19 (London, 1987), pp. 193–98.

12 For more information on Van Dyck's relationship to Rubens, see Susan J. Barnes, "The Young Van Dyck and Rubens," in *Anthony van Dyck,* edited by Arthur K. Wheelock, Jr. et al. (Washington, D.C., 1990/91), pp. 17–25; and Peter Sutton, *The Age of Rubens* (Boston, 1993), p. 31.

13 See Logan, *Peter Paul Rubens* (note 9), p. 222.

14 See Logan, *Peter Paul Rubens* (note 9), p. 223.

15 The eighteenth-century Swedish collector and connoisseur Count Carl Gustav Tessin,

who owned the Stockholm drawing, held this opinion. In his handwritten catalogue of 1749 he lists it as "de van Dyck."

16 For more on the Latin inscription, see Vliege, *Rubens Portraits* (note 11), p. 196.

17 Original Latin: *nota quod color pullus non est/ peculiaris Sinensium litteris sed/Patribus S Iesù exceptis tamen fascijs/ceruleis quae ceteris [que] communes sunt/Sinenses porro vestis colore non uno/sed quovis colore promiscue utanur./Si unum reserves flavum scilicet/qui proprius est Regis.* See Logan, *Peter Paul Rubens* (note 9), p. 222.

18 See Peterson, "What to Wear?" (note 7), p. 414; and Logan and Brockey, "Nicolas Trigault, SJ" (note 5), p. 157.

19 Scholars attribute the painting to Rubens and his workshop and relate it to a pendant painting of the Jesuit Petrus de Spira. Spira was a missionary in China and Goa, but did not travel with Trigault on his European tour. See Vliege, *Rubens Portraits* (note 11), pp. 191–94; Logan and Brockey, "Nicolas Trigault, SJ" (note 5), p. 159; and Logan, *Peter Paul Rubens* (note 9), p. 222.

20 An inscription on the painting identifies the sitter as Trigault and states that he was a Jesuit with the Chinese mission, who returned to Flanders in 1616, was painted in 1617, and died in 1627. See Logan, *Peter Paul Rubens* (note 9), p. 222.

21 See Logan and Brockey, "Nicolas Trigault, SJ" (note 5), p. 162.

22 George Dunne, *Generation of Giants: The Story of the Jesuits in China in the Last Decades of the Ming Dynasty* (Notre Dame, 1962), pp. 170–71.

23 Po-Chia Hsia, *A Jesuit in the Forbidden City: Matteo Ricci 1552–1610* (Oxford, 2010), p. 288.

24 See Logan and Brockey, "Nicolas Trigault, SJ" (note 5), p. 164.

25 See Dunne, *Generation of Giants* (note 22), p. 162.

26 See Hsia, *Jesuit in the Forbidden City* (note 23), p. 288; and Edmond Lamalle, "La Propagande du P. Nicolas Trigault en faveur des Missions de Chine (1616)," *Archivum Historicum Societatis Iesu* 9 (1940), p. 61.

27 See Logan and Brockey, "Nicolas Trigault, SJ" (note 5), p. 161.

28 The Jesuit Duarte de Sande, defending Matteo Ricci, expressed this sentiment in a letter written in Macau on January 16, 1596. See Liam Brockey, *Journey to the East: The Jesuit Mission to China* (Cambridge, 2007), p. 44.

29 See Dunne, *Generation of Giants* (note 22), p. 164.

30 Ibid.

31 Marcia Reed and Paula Demattè, eds., *China on Paper: European and Chinese Works from the Late Sixteenth Century to the Early Nineteenth Century* (Los Angeles, 2007), p. 10; and Alden, *Making of an Enterprise* (note 6), p. 141.

32 Roger Tennant, *A History of Korea* (London and New York, 1996), p. 177.

33 See Peterson, "What to Wear?" (note 7), p. 409. For the original quote by Ruggieri, see Tacchi Venturi, *Opera storiche* (note 8), p. 416.

34 Felice Stampfle, *Netherlandish Drawings of the Fifteenth and Sixteenth Centuries and Flemish Drawings of the Seventeenth and Eighteenth Centuries in the Pierpont Morgan Library* (Princeton, 1991), p. 146; and Anne-Marie Logan, *Flemish Drawings in the Age of Rubens: Selected Works from American Collections* (Wellesley, 1993), pp. 193–94. Wortley was the first to publish the Morgan sheet as Rubens's when she connects all of the drawings to the 1622 Jesuit procession in Antwerp. See Wortley, "Rubens's Drawings" (note 9), pp. 45–47.

35 For Logan's general method concerning the attribution of drawings to Rubens or Van Dyck, see Anne-Marie Logan, "Distinguishing the Drawings by Anthony van Dyck from Those of Peter Paul Rubens," in *Van Dyck 1599–1999: Conjectures and Refutations*, edited by Hans Vlieghe (Turnhout, Belg., 2001), pp. 7–28.

36 See Stampfle, *Netherlandish Drawings* (note 34), pp. 147–48.

37 See Lamalle, "La Propagande" (note 26), p. 60.

38 See Logan and Brockey, "Nicolas Trigault, SJ" (note 5), p. 163.

39 See Spence, *Memory Palace* (note 3), p. 176.

40 Brockey describes recruits entering China "in *literati* costumes, with long beards, hair grown out and tied on their heads in Chinese fashion." This implies the recruits were made

to look Chinese before they officially started their mission. See Brockey, *Journey to the East* (note 28), p. 78.

41 See Logan and Brockey, "Nicolas Trigault, SJ" (note 5), pp. 165–66; and Lamalle, "La Propagande" (note 26), p. 87.

42 See Wortley, "Rubens's Drawings" (note 9), pp. 45–47. Wortley used the festival to date all the drawings to 1622. This was before the sitters were identified as being portraits of Trigault and Schreck.

43 For a description of the Latin account, see Lamalle, "La Propagande" (note 26), pp. 49–120.

44 See Wortley, "Rubens's Drawings" (note 9), p. 44; and Karel Porteman, "Exotisme en spektakel: De Antwerpse jezuïetenfeesten van juli 1622," in *Vreemden vertoond: Opstellen over exotisme en spektakecultuur in de Spaanse Nederlanden en de Nieuwe Wereld*, edited by Johan Verberckmoes (Leuven, Belg., 2003), p. 116.

45 The costume is described (in translation) as "togas of cotton and wide, and also in girdles hanging down even to the ground," and further wearing on their heads an "almost square *pileus*." The fact that the Chinese costumes were made out of cotton, not silk, suggests that the costumes were most likely made in Antwerp. It seems likely that they were based upon silk robes imported by Trigault. See Wortley, "Rubens's Drawings" (note 9), p. 45.

46 See Porteman, "Exotisme en spektakel" (note 44), p. 116.

47 The identification of Rubens's costume as a *cheollik* was based on the opinion of Son Seok-ju, a Korean costume expert and founder of the Dankook University Museum that has vast holdings in Joseon dynasty costume. Professor Gwak published Son's opinion in his book on the Getty drawing. See Gwak Cha-seop, *Joseon cheongnyeon Antonio Korea, Rubenseu reul mannada* [The Joseon man, Antonio Corea meets Rubens](Seoul, 2004), pp. 88–100. See also Kim Young-Jae, chap. 2, herein.

48 See Gwak Cha-seop, *Josean cheongnyeon Antonio Korea* (note 47).

49 See Wortley, "Rubens's Drawings" (note 9), p. 44; Logan and Brockey, "Nicolas Trigault, SJ"

(note 5), p. 159; and Logan, *Peter Paul Rubens* (note 9), pp. 224–25.

50 Caun was born of noble origin in 1578 and taken as a prisoner of war to Japan when he was thirteen. He was baptized in Japan in 1603, and in 1612 sent to Beijing to await orders to initiate a Jesuit mission in Korea. Unable to gain entry into Korea, he returned to Nagasaki in 1620 where he was martyred in 1626 for his Christian beliefs. See Léon Pagès, *Histoire de la Religion Chrétienne au Japon depuis 1598 jusqu'à 1651: comprenant les faits relatifs aux deux cent cinq martyrs béatifiés le 7 julliet 1867*, vol. 1 (Paris, 1869), p. 612.

51 See Lamalle, "La Propagande" (note 26), pp. 49–120.

52 See Greg Irvine, "Japanese Diplomatic Relations with Europe," in *Encounters: The Meeting of Asia and Europe 1500–1800*, edited by Anna Jackson and Amin Jaffer (London, 2004), pp. 100–01; Adriana Boscaro, *Sixteenth-Century European Printed Works on the First Japanese Mission to Europe: A Descriptive Bibliography* (Leiden, Neth., 1973); Peter C. Mancall, ed., *Travel Narratives from the Age of Discovery: An Anthology* (Oxford, 2006), p. 43; and Marco Musillo, "Travels from Afar through Civic Spaces: The Tensho Embassy in Renaissance Italy," in *Western Visions of the Far East in a Transpacific Age (1522–1671)*, edited by Christina H. Lee (Farnham, Brit., 2012), forthcoming.

53 Chun Hae-jong, "Sino-Korean Tributary Relations in the Qing Period," in *World Order: China's Foreign Relations*, edited by John King Fairbank (Cambridge, 1968), pp. 90–111; and Gari Ledyard, "Korean Travelers in China over Four Hundred Years, 1488–1887," *Occasional Papers on Korea* 2 (1974), pp. 1–42.

54 See Ledyard (note 53), p. 4.

55 See Chun, "Sino-Korean Tributary Relations" (note 53), pp. 103–05.

56 See Hsia, *Jesuit in the Forbidden City* (note 23), p. 209.

57 Following Confucian notions of filial piety, the Chinese and Koreans did not shave or cut their hair. See Gallagher, *China in the 16th Century* (note 4), pp. 77–78.

58 According to Evers, Rubens acquired de Bry's book in 1613. See Hans Gerhard Evers, *Peter Paul Rubens* (Munich, 1942), p. 216; and Julius Held, *Oil Sketches of Peter Paul Rubens: A Critical Catalogue*, vol. 1 (Princeton, 1980), p. 562.

59 The painting was to be alternated with *The Miracles of St. Ignatius Loyola* by the means of a pulley system. See Knaap, "Meditation, Ministry" (note 2), p. 175.

60 See Alden, *Making of an Enterprise* (note 6), p. 42.

61 Georg Schurhammer, *Francis Xavier: His Life and Times*, trans. M. Joseph Costelloe, vol. 2 (Rome, 1973–82), pp. 193–94.

62 Graham Smith, "Rubens' Altargemälde des Hl. Ignatius von Loyola und des Hl. Franz Xavier für die Jesuitenkirche in Antwerpen," *Jahrbuch der Kunsthistorischen Sammlungen in Wien* 65 (1969), pp. 39–60.

63 Tursellinus describes these pagans as Brahmans that are convinced by the saint's arguments. See Graham Smith (note 62), p. 53; and Christine M. Boeckl, "Plague Imagery as Metaphor for Heresy in Rubens' *The Miracles of Saint Francis Xavier*," *Sixteenth Century Journal* 27, no. 4 (1996), p. 983.

64 Francis Xavier was beatified in 1619 and canonized in 1622. See Boeckl (note 63), p. 982.

65 See Christine Göttler, "'Actio' in Peter Paul Rubens' Hochaltarbildern für die Jesuitenkirche in Antwerpen," in *Barocke Inszenierung*, edited by Joseph Imorde, Fritz Neumeyer, and Tristan Weddingen (Emsdetten and Zürich, 1999), p. 13; and Boeckl, "Plague Imagery as Metaphor" (note 63), p. 982.

66 For a discussion of how Dutch, German, and Italian collectors of curiosities regarded foreign objects as generic exotica, see Jessica Keating and Lia Markey, "'Indian' Objects in Medici and Austrian-Hapsburg Inventories: A Case-Study of the Sixteenth-Century Term," *Journal of the History of Collections* 23 (2001), pp. 283–300; and Claudia Swan, "Exoticism at Work: Dutch Culture in a Global Perspective 1600–1650" (unpublished paper given at the Historians of Netherlandish Art Conference, Amsterdam, May 29, 2010).

67 See Goldner, *European Drawings 1* (note 9), pp. 210–12; and Logan, *Peter Paul Rubens* (note 9), p. 212.

Korean Contacts with Europeans in Beijing, and European Inspiration in Early Modern Korean Art

Burglind Jungmann

At the beginning of the nineteenth century, the court painter Jang Han-jong (act. late 18th to early 19th century) painted an eight-panel screen (fig. 31) in an illusionist style employing Western techniques of shading and perspective. With its long, heavy curtains that open the view onto cases containing books and precious collectibles, this so-called "study screen" (*munbangdo*) exemplifies the inspiration early modern Korean artists received from Baroque painting.[1] It was, however, created about two hundred years after Rubens drew the *Man in Korean Costume* (see fig. 1) and thus represents a fairly late reflection of Baroque concepts and techniques. Evidence of earlier explorations of European art by Korean painters is fragmentary and its impact less obvious. We therefore have to rely on historical sources that attest to Korean contacts with Europeans. An examination of the circumstances under which they took place and the interests on both sides will help us to get an idea of the Korean reception of European art in earlier centuries.[2]

Early Korean–European Contacts and the Chinese World Order

Several important studies have explored the impact of Jesuit sciences, religion, and intellectual culture on Joseon dynasty (1392–1910) Korea.[3] They indicate that the first discussion of Europe and Christianity appeared in the texts of Joseon scholars in the early seventeenth century. The main channels of contact were diplomatic missions, which were sent three times a year on average from Seoul to

FIGURE 31 DETAIL AND OVERLEAF
Jang Han-jong (Korean, act. late 18th to early 19th century), *Chaekgado* (*Scholarly Accoutrements*, or Books and scholarly utensils behind a curtain), Joseon dynasty, early 19th century. Eight-panel screen, colors on paper, 195 × 361 cm (76¾ × 142⅛ in.). Yongin, Korea, Gyeonggi Provincial Museum, 6672

Beijing and included court painters. When in 1603 Joseon envoys received a copy of Matteo Ricci's *Complete Map of the World*, high officials in Seoul were shocked by the fact that the earth was round and the world extended far beyond East Asia, China no longer being at its center. Yet, a large reproduction of the map (fig. 32), painted in 1708, attests that the new worldview was accepted over time.

During the late sixteenth and early seventeenth century, the Joseon political and cultural elite were unable to pay much attention to the knowledge and skills of the Jesuits at the Chinese court, because Korea was, in Gari Ledyard's words, an "armed camp."[4] Always vulnerable to the hegemonic desires of its neighbors, the peninsula was invaded twice, during the Imjin War (1592–98) by Japanese armies under the command of Toyotomi Hideyoshi (1537–1598), and again in 1627 and 1636 by the Jurchen Manchus. While Hideyoshi was unable to fulfill

FIGURE 32 *Complete Map of the Myriad Countries of the World*, Joseon dynasty, 1708. Hand-copied after map by Matteo Ricci (Italian, 1552–1610). Eight-panel screen, ink and colors on paper, 172 × 531 cm (67¹¹⁄₁₆ × 209¹⁄₁₆ in.). Seoul National University Museum, Treasure 849

his ultimate wish to conquer the Chinese Empire, the Manchus were more successful and established themselves as the Qing dynasty in 1644. One of the most important early encounters between a Korean and a Jesuit priest is related to the Manchu invasions. Crown Prince Sohyeon was taken hostage by the Manchus in 1636 and became acquainted in Beijing with the Jesuit Adam Schall von Bell (1591–1666), one of the most prominent astronomers of the era. When the prince was released in 1645 he brought European books on sciences, together with religious articles and several Chinese Catholic servants. The fact, however, that he was assassinated shortly after his return, indicates how much conservative forces feared the possible impact of the unknown religion and worldview. The earliest known written exchange between a Joseon scholar and a European Jesuit scientist also took place during this era of unrest. In 1631 the Korean envoy Jeong Du-won (b. 1581) received books on Western astronomy and geography, world maps, a telescope, a sundial, an automatic striking clock, and a pair of guns from the Jesuit João Rodrigues, and his assistant followed up with an exchange of letters discussing astronomical theory and the Western method of calendar calculation with Rodrigues. Another important encounter happened outside the diplomatic channels in 1653 when a Dutch sailor of the East India Company was shipwrecked on Jeju Island. While Joseon officials were at a loss for how to deal with the unwanted strangers, this event became important for the European side, because the secretary on board, Hendrik Hamel, after escaping with a group of surviving crew members after thirteen years of captivity, published a book on his adventures, the first Western account of Korea.[5]

By the end of the seventeenth century, Joseon intellectuals had become increasingly curious about Western sciences and had developed more concrete ideas of what to accept. They mostly participated in a movement to reform the state-supporting Neo-Confucian ideology called *Silhak* ("Practical Learning"). Scholars published texts and encyclopedias on native geography, history, and social conditions, and many of them absorbed the Western knowledge that came from China into their new ideas. A main representative, Yi Ik (1681–1763), being well aware of the connections between Catholic religion and Jesuit science, rejected the former but showed much interest in the latter. Yet, he concluded that within the Confucian ideological edifice, science was a mere "craft."[6]

Eighteenth-century travel diaries attest to the curiosity of Korean visitors to Beijing regarding Jesuits' skills. Hong Dae-yong (1731–1783), a young mathematician who traveled to Beijing in 1765–66, describes his visit to the South Church where trompe-l'oeil wall paintings deeply impressed him:

> As you go in the gate, there is a brick wall in the east about twenty feet high. A hole had been knocked through the wall, making a gate. Through this half open gate could be seen some multi-storied buildings on the other side, their balcony railing piled up on top of each other. …I went forward a few steps and inspected it closely and indeed it was a painting. …I have heard that the marvel of Western painting is not just in its superhuman skill and ingenuity, but in its method for calculating the method of reduction, which comes solely from mathematics.[7]

In spite of his admiration for the wall paintings, Hong Dae-yong strongly rejected the iconography of the crucified Jesus whom he perceived, like other Chinese and Korean Confucian scholars, as a rebel and unfilial son who had lawfully been executed.[8] Moreover, even though Hong's remarks give evidence of his great astonishment, the illusionism of European painting was merely taken as exotic, a playful way of fooling the viewer, a mere "craft," just as the sciences were for Yi Ik. European ideas did not seriously affect the East Asian idea of painting as an art, which was, through its close connections with calligraphy and poetry, profoundly rooted in *literati* culture. Nevertheless, Joseon painters utilized European skills, selectively integrating them into their own concepts.

European Elements in Joseon Painting

Painted and mounted on an eight-panel screen, the *Complete Map of the Myriad Countries of the World* (see fig. 32) not only is the oldest surviving example of a Jesuit map in Korea but also gives evidence of the adaptation of European painting techniques in the early eighteenth century. Various animals representing exotic lands, including an elephant, a winged mythical beast (fig. 33), a crocodile, a goose, and a rhinoceros, can be well recognized. While the painter closely followed Ricci's *Complete Map of the World*, he also had enough understanding of shading techniques to depict the creatures in a convincing way. The twisted body and turning head of the mythical beast, for instance, convey a sense of volume

and movement in space. No other eighteenth-century Korean painting comes as close to European iconography and painting styles as this screen. Yet, given the quality of its execution, other paintings and sketches may well have preceded and followed it.[9]

Although not as explicit in their connection with European painting, other Korean eighteenth-century paintings do include "foreign" inspiration. Most prominent in this regard is a genre that served entirely different purposes in East Asia and Europe: portrait painting.[10] While European portraits were commissioned as representations of authority, wealth, and power, to be proudly presented to the public, East Asian portraits are closely related to religious purposes and Confucian ancestor worship and thus only accessible to select viewers during special rituals. Their power rather lay in their secrecy, not in their open display. However, Qing emperors, obviously inspired by the vivid exchange with European

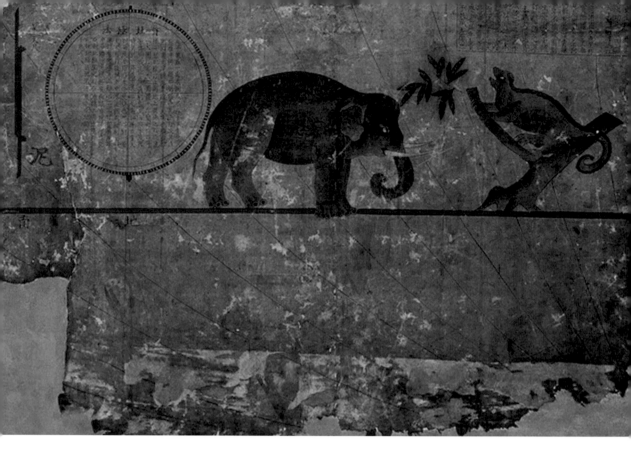

FIGURE 33 Mythical Beast (detail, fig. 32)

aristocrats and by their Jesuit court painters, had their portraits produced in large numbers, taking on different roles and disguises. Together with visual representations of successful battles and splendid court ceremonies, done in Western illusionistic techniques or even commissioned in Europe, these images served the Manchus as a propagandistic instrument to justify their rule of the Chinese Empire. The portrait of *The Kangxi Emperor Reading* (fig. 34) depicts the ruler as a scholar, showing him in simple dress in front of bookshelves. This portrait is not only a good example of European-inspired Chinese portraiture but also an interesting forerunner of the study screens that became popular in Korea. Joseon scholar-officials, who looked upon the Qing as "barbarian" rulers and regarded themselves as the true custodians of the Confucian way, were much more conservative in regard to portraiture. Yet, Korean envoys liked to commission their portraits from Chinese painters during their stay in Beijing as souvenirs of their

Unknown maker (Chinese, act. early 18th century), *The Kangxi Emperor Reading*, Qing dynasty, early 18th century. Hanging scroll, ink and colors on silk, 138 × 106.5 cm (54 5/16 × 41 15/16 in.). Beijing, The Palace Museum, Gu6411

Yun Du-seo (Korean, 1668–1715), *Self-Portrait*, Joseon dynasty, 18th century. Ink and light colors on paper, 38.5 × 20.5 cm (15 3/16 × 8 1/16 in.). Haenam, Korea, Yun Family Collection Nogudang, National Treasure 240

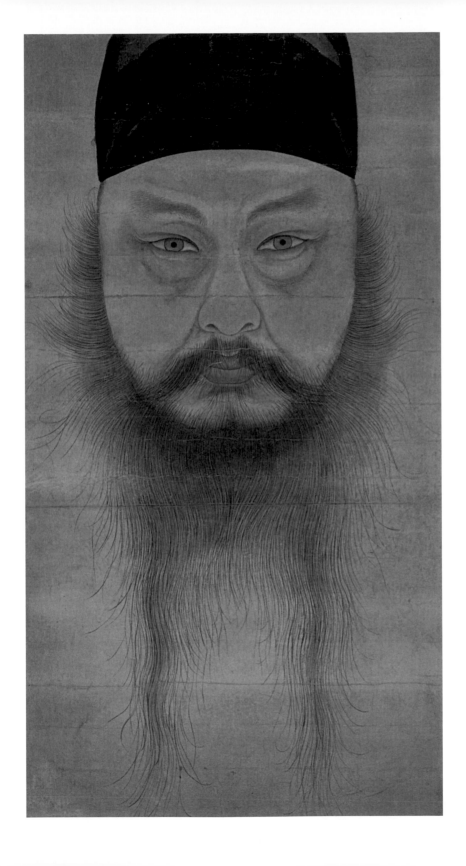

journey.[11] This practice and the experience of court painters accompanying missions to China led to an acceptance of European ideas into this conservative genre. Moreover, scholar-painters who were close to the *Silhak* movement, such as Yun Du-seo (1668–1715), were interested in the Western sciences, technical devices, and new painting techniques.

The earliest surviving Korean self-portrait, by Yun Du-seo (fig. 35), shows a bearded man with a full, round face and dark hair, probably in his thirties. Art historians generally regard this portrait as a preliminary version of a more formal portrait, but it might also be considered a study the painter made just for himself. [12] Shown in a frontal position, Yun seems to scrutinize his own likeness in a mirror: every hair is carefully drawn with fine lines, and the observant eyes give the viewer an impression of vital presence. The skin-colored wash to shade Yun's face is reminiscent of the red chalk Rubens used to model the face in his *Man in Korean Costume* (see fig. 5). Lighter-colored areas on the silken black headgear and the sitter's forehead attest to the painter's attention to light effects. Korean portraiture always strived for the utmost accuracy in reproducing the sitter's likeness—a basic requirement for its function in ancestor rituals—but Yun Du-seo evidently also integrated ideas of Western painting here. Yun was closely acquainted with the *Silhak* movement through his father-in-law, Yi Su-gwang (1563–1628), a scholar credited with the first *Silhak* publications, and his acquaintance with Yi Ik.[13] It is thus most likely that Yun Du-seo received information about European painting through *Silhak* scholars.[14]

In the latter half of the eighteenth century, European elements were more widely integrated into Korean painting, a development that was supported at the royal court by King Jeongjo (r. 1776–1800). The *Portrait of Seo Jik-su* (fig. 36), done in 1796 by Yi Myeong-gi (b. 1756) and Kim Hong-do (1745–after 1806), is an example of this era and one of only a few extant standing portraits.[15] Although

FIGURE 36 Yi Myeong-gi (Korean, b. 1756) and Kim Hong-do (Korean, 1745–after 1806), *Portrait of Seo Jik-su*, Joseon dynasty, 1796. Hanging scroll, ink and light colors on silk, 148.8 × 72.4 cm (58⁹⁄₁₆ × 28½ in.). Seoul, National Museum of Korea 국립중앙박물관, Treasure 1487

the three-quarter view is common in traditional Korean portraiture, Seo Jik-su's (b. 1735) posture and the arrangement of his feet may have been inspired by European-Chinese trends. The subtle shading of the face, hat, coat, and socks give an impression of space and volume, while the careful rendering of the eyes, eyebrows, the freckles on Seo's left cheek, and the shiny quality of the silken fabric attest to the painters' knowledge of European naturalistic rendering. Historical records reveal that both Kim Hong-do and Yi Myeong-gi had been allowed to join an embassy to China in 1789 where they must have had ample opportunity to study European art.[16]

In his inscription in the upper-right corner, Seo states that Yi Myeong-gi painted the face and Kim Hong-do the body.[17] Although the two artists were undoubtedly the most famous court painters of their times, Seo Jik-su complains that they were not able to capture his spirit. To "capture the spirit," or convey the inner qualities of the sitter, was of the highest priority and it had to be kept in balance with the "naturalistic" rendering of his outer appearance.[18] Therefore, dramatic light effects, so often found in European portraiture, were not appreciated. Even the Emperor Qianlong (r. 1735–96), who strongly promoted Jesuit painters and their methods at his court, objected to strong shading on their face.[19] This profound aversion for dramatic effects, as well as the display of emotions, is rooted in the Confucian idea of "nonattachment." *Portrait of Seo Jik-su* is thus a good example of the painters' efforts to integrate European techniques into the traditional concept of portraiture.

The *Portrait of Yi Gwang-sa* (fig. 37), made by Shin Han-pyeong (b. 1726) in 1774, when Yi Gwang-sa (1705–1777) was seventy years old (by Korean count, which adds an extra year), adheres more to traditional methods.[20] The face appears flatter, and the outlines of nose and mouth, which in the *Portrait of Seo Jik-su* (see fig. 36) blend into the shading of the skin, are dark and distinct. The shading of the

FIGURE 37 Shin Han-pyeong (Korean, b. 1726), *Portrait of Yi Gwang-sa*, Joseon dynasty, 1774. Hanging scroll, ink and colors on silk, 66.8 × 53.7 cm (26⁵⁄₁₆ × 21⅛ in.). Seoul, National Museum of Korea 국립중앙박물관, Treasure 1486

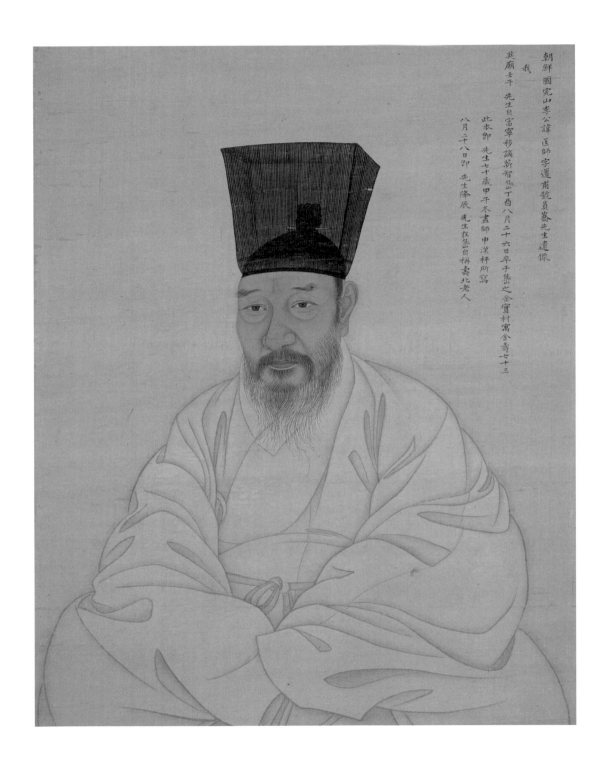

朝鮮國完山李公諱匡師字道甫號員嶠先生遺像

我

英廟壬午 先生自富寧移謫薪智島丁酉八月二十六日卒于謫之金寶村壽金壽七十三

此本卽 先生七十歲甲午冬畫師申漢枰所寫

八月二十八日卽 先生降辰 先生在謫自稱壽北老人

coat is simpler, the impression thus flatter, too. Moreover, the translucent head-dress, one of the less formal hats Joseon dynasty scholars would use at home, resembles the hat Rubens's *Man in Korean Costume* (see fig. 5) wears, similarly allowing a glimpse at the sitter's topknot. Shin Han-pyeong represents an earlier generation of court painters and Shin's portrait precedes Yi's by roughly twenty years. However, because of the detailed depiction of skin wrinkles, it is regarded as a first stepping-stone toward the integration of Western techniques.[21]

In early modern East Asia, landscape painting enjoyed the highest regard among the various genres. Recent investigation has revealed that Jeong Seon (1676–1759), the most celebrated Joseon dynasty landscape painter, was employed in the Bureau of Astronomy at a time when scholars started to combine traditional East Asian cosmological ideas with those of Western astronomy and geography.[22] An album leaf of a place at the east coast of the peninsula, "Sunrise at Munam," of 1742 (fig. 38) shows a group of travelers sitting beneath a formation of large stones, the "Gate Rock" (Munam), enjoying the sunrise above the sea. The small painting is done in Jeong Seon's signature brushwork, with long strokes outlining the shapes of rocks, thick wet dots for vegetation, and parallel, rhythmic vertical and horizontal strokes for pine trees. What is peculiar, however, about this album leaf is the way in which Jeong Seon represented the reflection of the blue sky on the water and the red and orange coloring in the sky, caused by the rising sun. In East Asian ink painting, reflections—considered illusions that are not integral to the landscape itself—are usually not shown. Where should Jeong Seon have gotten this exceptional idea of red-and-blue-tinted clouds if not from a Baroque painting, similar to those by Rubens? Again, as in portraiture, the effect is less dramatic and well integrated into the overall calm atmosphere.

Jang Han-jong's *Chaekgado* (*Scholarly Accoutrements*, or Books and scholarly utensils behind a curtain; see fig. 31), briefly mentioned at the outset, can be linked to the European genre of still life.[23] Popular all over Europe during the Renaissance and Baroque, still lives represented the desire of the nobility and wealthy commoners to show off their wealth and exotic possessions, such as tulips from Turkey or porcelain from China, an intention obviously shared by Jang's *Chaekgado*.[24] Although this screen is the earliest extant example ascribed to a certain artist, it builds on earlier traditions that can be traced through textual sources to

FIGURE 38 Jeong Seon (Korean, 1676–1759),
"Sunrise at Munam," from the album
*Transmitting the Spirit of Sea and
Mountain*, Joseon dynasty, 1742. Ink and
light colors on silk, 33.1 × 25.7 cm (13 1/16 ×
10 1/8 in.). Seoul, Gansong Art Museum

court art under the reign of King Jeongjo, again pointing to the king's favorite Kim Hong-do. Jang Han-jong, in turn, was related to Kim and collaborated with him on important projects.[25] Korean study screens share with Dutch and Flemish still lives a taste for luxury and the exotic (see fig. 45); rather than representing an actual display, they are artificially arranged like the sumptuous bouquets whose flowers do not bloom at the same time. The items depicted—Chinese porcelain and bronzes, books, scrolls, the jade carp and coral branch, among others—appear in exactly the same shapes and colors in a number of other screens datable to the nineteenth century.[26] Painters obviously used sketchbooks containing a repertoire of precious objects, rare flowers, and fruit. It is highly likely that even Jang Han-jong did not paint the real objects but worked from the models of a previous artist, such as Kim Hong-do.

Another interesting aspect is the question of display. Although collecting has a long history in East Asia, precious items were usually hidden from view and only taken from storage, unwrapped, and appreciated on special occasions. Again we find a certain "power of secrecy" stemming from limited access. In China the open display of a collection became fashionable during the Qing dynasty, most probably through inspiration from Europe. Whether actual objects were also on display at the Joseon palace still needs to be researched. There is, however, no doubt that only few people could afford exotic, luxurious objects and that the screens often served as substitutes.[27]

The adaptation of thought, visual elements, and painting techniques from Europe via China is a fascinating process of "cultural translation."[28] Genres were carefully chosen and visual elements were appropriated to local circumstances and conventions. Chinese emperors employed Jesuit painters and their astonishing European methods to represent the splendor of their reign, yet they strongly influenced their production in order to gain results desirable to their cultural traditions. Similarly, Joseon painters and their patrons were guided by their own conventions and taste. They were curious about new ways of viewing and representing the world, but their traditions, in particular the idea of "nonattachment"—of not being absorbed by emotions—prevented them from a wholesale acceptance of European painting. Instead, they blended what they had learned with their traditional ways and achieved astounding results.

1 See for example Rubens's *Portrait of Nicolas Trigault*, now in the Musée de la Chartreuse, Douai, discussed by Stephanie Schrader in chap. 3, p. 44, herein.

2 The most important study of Western elements in Joseon painting is Yi Song-mi's *Joseon sidae geurim sok ui seoyang hwabeop* (Seoul, 2000). For a more recent evaluation, see also Jang Jin-seong, "Joseon hugi hoehwa wa munhwajeok hogisim," *Misulsa nondan* 32 (2011), pp. 163–89.

3 Gari Ledyard, "Korean Travelers in China over Four Hundred Years, 1488–1887," *Occasional Papers on Korea* 2 (1974); Donald L. Baker, "Jesuit Science through Korean Eyes," *Journal of Korean Studies* 4 (1982/83); Peter H. Lee, ed., *Sourcebook of Korean Civilization*, vol. 2, *From the Seventeenth Century to the Modern Period* (New York, 1996), pp. 109–57; Jung Jae-hoon, "Meeting the World through Eighteenth-Century *Yŏnhaeng*" in *Seoul Journal of Korean Studies* 23:1 (June 2010), pp. 51–69; Oak Sung-Deuk, "Images of the Cross in Early Modern Korea: The Geomantic Prophecy of the *Chŏnggam-nok* and the Protestant Flag of the Red Cross," in *Journal of Korean Religions*, vol. 1, nos. 1 & 2 (September 2010), pp. 117–61.

4 Gari Ledyard, *The Dutch Come to Korea* (Seoul, 1971), p. 46.

5 The book was published in Amsterdam and Rotterdam in 1668. For a translation from the Dutch, see Ledyard, *Dutch Come to Korea* (note 4), pp. 205–26. Interestingly, it caused representatives of the East India Company to consider direct trade with the peninsula.

6 Among the various groups who rivaled for power at the Joseon court, *Silhak* scholars were comparably weak, as they mostly belonged to marginalized groups of the intellectual elite. For an overview of *Silhak* scholarship, see Carter J. Eckert et al., *Korea Old and New: A History* (Seoul, 1990), pp. 164–71. For Yi Ik's selective adaptation of European ideas, see Baker, "Jesuit Science" (note 3), pp. 229–30.

7 Translation by Gari Ledyard, cited from Kay E. Black and Edward W. Wagner, "Court Style Ch'aekkŏri," in *Hopes and Aspiration: Decorative Painting of Korea* (Asian Art Museum of San Francisco, 1998), p. 26. For further information about Hong's travel diary, see Gari Ledyard, "Hong Taeyong and His Peking Memoir," *Korean Studies* 6 (1982), pp. 63–103. For engravings of the South Church, see Gauvin Alexander Bailey, *Jesuit Art and Architecture in Asia*, in *The Jesuits and the Arts, 1540–1773*, edited by John W. O'Malley and Gauvin Alexander Bailey (Philadelphia, 2005), pp. 332–35.

8 See Oak, "Images of the Cross" (note 3), pp. 117–61.

9 The map was painted on royal order. The inscriptions on the outermost panels include the preface of Matteo Ricci and a preface of Director of the Bureau of Astronomy. See Bae Woo Sung, "World Views and Early Cartography," in Han Young-woo, Ahn Hwi-joon, and Bae Woo Sung, *The Artistry of Early Korean Cartography*, trans. by Choi Byonghyon (Larkspur, Calif., 1999), pp. 96–101. See also Gari Ledyard, "The History of Korean Cartography," in *The History of Cartography*, vol. 2, book 2, *Cartography in the Traditional East and Southeast Asian Societies*, edited by J.B. Harley and David Woodward (Chicago, 1987–2007), pp. 250–54. The Getty Research owns another Korean reproduction of a world map by Ferdinand Verbiest (1623–1688), which is also based on Ricci's map. See Marcia Reed and Paola Demattè, eds., *China on Paper: European and Chinese Works from the Late Sixteenth to the Early Nineteenth Century*, exh. cat. (Los Angeles, 2007), pp. 190–95.

10 For information on Korean portraiture, see the essays by Cho In-soo, Gang Gwan-sik, and Lee Soomi in *International Journal of Korean Art and Archaeology*, vol. 5 (2011).

11 See Cho In-soo, "Transmitting the Spirit: Korean Portraits of the Late Chosŏn Period," *Embracing the Other: The Interaction of Korean and Foreign Cultures* (Seoul: The Academy of Korean Studies, 2002), pp. 565–75. Several of these portraits are extant and show a variety of compositions and styles. See also two portraits

of Kim Yuk (1580–1658) in *Josanghwa ui bimil* (*The Secret of the Joseon Portraits*), exh. cat. (Seoul, National Museum of Korea, 2011), pls. 136, 141.

12 The material, oiled paper, was normally used for preliminary sketches. Moreover, old photographs and scientific examinations show lines of the coat that have faded. For a scientific study, see Cheon Ju-hyeon et al., "Yun Du-seo jahwasang ui pyohyeon gibeop mit allyo bunseok," *Misul jaryo* 74 (2006), pp. 81–95. Lee Tae Ho regards Yun's self-portrait as a milestone in the development of Korean portraiture for its integration of Western techniques. See his "Portrait Paintings in the Joseon Dynasty: With a Focus on Their Style of Expression and Pursuit of Realism," *Korea Journal* (Summer 2005), pp. 112–14.

13 Yi Su-gwang visited China three times as an envoy and studied the works of Jesuit priests. He mentions Matteo Ricci's treatise on Catholicism in his *Jibong yuseol* (*Topical Discourses of Jibong*) of 1614, a discussion of astronomy, geography, Confucianism, botany, society, and government of former Korean dynasties. Moreover, Yun's great-grandson Jeong Ya-gyong (1762–1836) later became one of the first Koreans to convert to Catholicism.

14 The Chinese library still kept at his family seat in Haenam gives evidence of the diversity of sources that he had at his disposal. See Cha Mi-ae, "Haenam Nogudang sojang 'Gwangyu jibyo' ui gochal," *Yeoksahak yeongu* (2007), pp. 31–70.

15 For an X-ray examination that reveals how Kim Hong-do applied color on the rear side of the silk, see Lee Soomi, "Two Stages in the Production Process of Late Joseon Portraits: Sketches and Reverse Coloring," in *International Journal of Korean Art and Archaeology*, vol. 5 (2011), p. 53 and fig. 17.

16 Their inclusion in the embassy was most likely related to a large building project of King Jeongjo that included brick architecture and Buddhist painting. See Oh Ju-seok, *The Art of Kim Hong-do: A Great Court Painter of 18th Century Korea* (Chicago, 2005), pp. 162–66; and Jung, "Meeting the World" (note 3), pp. 63–65.

17 For a transcription and Korean translation of the inscription by art historian Lee Soomi, see *Joseon sidae chosanghwa* (*Joseon Portraits*), vol. 1, *Gungnip jungang bangmulgwan Hanguk seohwa yumul dorok* (*Korean Paintings and Calligraphy of the National Museum of Korea*), vol. 15 (Seoul, 2007), pp. 207–08.

18 Gang Gwan-sik explains how Joseon scholars reflected upon the tension between the representation of a person's outer picture and his inner qualities in his "Self-Cultivation in the Portraits of Joseon Literati Scholars," *Korea Journal* (Summer 2005), pp. 182–215.

19 Yang Boda notes that the emperor was both fascinated and put off by the relief effect of chiaroscuro and particularly detested contrasts in the shadows of this face. See his "The Development of the Ch'ienlung Painting Academy," in *Words and Images: Chinese Poetry, Calligraphy, and Painting* (New York, 1991), p. 349.

20 Yi Gwang-sa is remembered as a poet, calligrapher, and painter whose career abruptly ended when he was accused of conspiracy and banished in 1755, while Shin Han-pyeong is the father of the famous genre painter Shin Yunbok (b. 1758).

21 See Lee Tae Ho, "Portrait Paintings" (note 12), pp. 129–30.

22 Gang Gwan-sik, "Gyeomjae Jeong Seon ui cheonmunhak gyeomgyosu chulsa wa 'Geumgang jeondo' ui jeonmun yeokhakjeok haeseok," *Misulsa hakbo* 27 (2006), pp. 167–72 and figs. 14, 15. Gang discusses in particular Jeong's famous *Complete View of the Diamond Mountains* in relation to diagrams published by a colleague showing a fusion of Eastern and Western astronomical ideas.

23 See Kay E. Black and Edward W. Wagner, "*Ch'aekkŏri* Paintings: A Korean Jigsaw Puzzle," in *Archives of Asian Art* 46 (1993), pp. 63–75; and by the same authors, "Court Style *Ch'aekkŏri*" (note 7), pp. 23–35.

24 See Jang, "Joseon hugi hoehwa" (note 2), pp. 176–80.

25 Kim Hong-do is mentioned as a painter who excelled in this genre. Jang Han-jong was a descendant of the court painter Jang Pil-ju

(dates unknown), Kim's maternal grandfather. The two painters also worked together on important projects for King Jeongjo. See Jin Jun-hyeon, *Danwon Kim Hongdo yeongu* (Seoul, 1999), pp. 59, 424, 429, 624–25.

26 There is, of course, no doubt that actual objects served originally as models. Bang Byeong-seon has, for instance, identified certain Chinese porcelains in his "Yi Hyeong-nok ui chaekka munbangdo palgokbyeong e natanan Jungguk Doja," *Gangjwa misulsa* 28 (2007), pp. 209–38. Numerous screens by late-nineteenth-century painters, especially by Yi Hyeong-nok and Gang Dal-su, contain the same objects in ever-changing variations. See Black and Wagner, "*Ch'aekkŏri* Paintings" (note 23); and by the same authors, "Court Style *Ch'aekkŏri*" (note 7).

27 Again we find a parallel in European Baroque. Gisela Luther speaks of "imaginary collections" in her essay, "Stilleben als Bilder der Sammelleidenschaft," in *Stilleben in Europa*, exh. cat. (Münster, 1979), pp. 121–26.

28 For the concept of "cultural translation," see Stuart Hall, "Museums of Modern Art and the End of History," in Stuart Hall and Sarat Mahara, *Modernity and Difference*, inIVAnnotations 6 (London: inIVA, 2001), pp. 8–23.

ITINERARIO,

Voyage ofte Schipvaert / van Jan Huygen van Linschoten naer Oost ofte Portugaels In-

dien: inhoudende een corte beschrijvinghe der selver Landen ende Zee-custen/ met aen-
wijsinge van alle de voornaemde principale Havens/Revieren/hoecken ende plaetsen/ tot noch
toe vande Portugesen ontdeckt ende bekent: Waer by ghevoecht zijn / niet alleen die Conter-
feytsels vande habyten/drachten ende wesen/so vande Portugesen aldaer residerende/ als van
de ingeboornen Indianen/ende huere Tempels/Afgoden/Huysinge/met die voornaemste
Boomen/Vruchten/Krupden/Speecerpen/ende diergelijcke materialen/ als ooc die
manieren des selfden Volckes/so in hunnen Godts-diensten/ als in Politie
en Huijs-houdinghe: maer ooc een corte verhalinge van de Coophan-
delingen hoe en waer die ghedreven en ghevonden worden/
met die ghedenckweerdichste geschiedenissen/
voorghevallen den tijt zijnder
residentie aldaer.

Alles beschreven ende by een vergadert, door den selfden, seer nut, oorbaer,
ende oock vermakelijcken voor alle curieuse ende Lief-
hebbers van vreemdigheden.

t'AMSTELREDAM.

By Cornelis Claesz. op't VVater, in't Schrijf-boeck, by de oude Brugghe.

Anno CIↃ. IↃ. XCVI.

The Place of the "Exotic" in Early-Seventeenth-Century Antwerp

Christine Göttler

Antwerp as Market of the World

Considered a model for all other cities, the "laudable and far-famed city of Andwerp" is given a central place in the *Descrittione di tutti i Paesi Bassi* (Description of the Low Countries), first published in Antwerp in 1567 by the Florentine merchant and humanist Lodovico Guicciardini (1521–1589). Among the "causes of the great wealth that Andwerp has grown to," Guicciardini points to a decisive event in the history of overseas expansion which initiated the forceful intervention by the Portuguese into the spice trade: the finding of a sea route to Calicut on the west coast of India by circumnavigating the Cape of Good Hope. Although mentioned by Pliny the Elder, knowledge of this route had long been lost. After 1499, news about the Portuguese seaman Vasco da Gama's successful voyage spread quickly through Europe to the dismay of Portugal's rivals, particularly Venice, the trading port which had "before the Portugals voiage into the Indias furnished all Christendome of spices," as Guicciardini astutely observes. The Portuguese crown's subsequent decision to move its staple market for spices to Antwerp drove the city's spectacular rise: "Thus Andwerp by this occasion beginning to be greatly frequented . . . and so by little and little all strangers (a few excepted) left Bruges and went to Andwerp, with no lesse commodity to this cittie, than discommodity to that."[1]

FIGURE 39 Title page from Jan Huygen van Linschoten (Dutch, 1563–1611), *Itinerario, Voyage ofte Schipvaert van Jan Huygen van Linschoten naer Oost ofte Portugaels Indien* (Amsterdam, 1596). Hand-colored engraving, 29.6 × 19.3 cm (11⅝ × 7⅝ in.). San Marino, California, Huntington Library, 132666

In Guicciardini's account, the many foreign merchants who flocked to Antwerp to profit from Portugal's lucrative trade in spices transformed the urban center into a "world city" where new goods, new merchandise, and new information were circulated and exchanged. In turn, the flow of commodities from European and overseas markets, along with the competition among highly specialized artists and craftsmen, affected Antwerp's visual and material culture, making the city into a center of new forms of knowledge and expertise.[2] In 1577 the Calvinist city fathers described Antwerp as "not only the first and principal commercial city of all Europe, but also the source, origin, and storehouse of all goods [*schuyre van alle goeden*], riches and merchandise, and a refuge and nurse of all arts, sciences, nations and virtues."[3] Harold J. Cook has argued that the association between goods and riches, on the one hand, and arts, sciences, and virtues, on the other, points to a specific culture of knowledge in which various kinds of expertise were intricately intertwined. In the course of the sixteenth century, "virtue" became a key term in all kinds of discourses defining the abilities and skills of diverse urban groups such as merchants, traders, craftsmen, artists, physicians, and apothecaries who self-consciously engaged with the material and natural world.[4]

Proceeding from such observations, this essay explores how Antwerp's world of virtues and exotic goods was displayed and reinforced, both in public and private spaces and in the visual arts. In the form of short case studies, some iconographies and visual images are introduced here that reference the idea of Antwerp as a *stapel-huys* (storehouse) where "exotic commodities" brought back from all parts of the world were accumulated, traded, and collected.[5] The focus is mainly the 1610s, when, from his Antwerp studio, the Flemish artist Peter Paul Rubens created his elaborate, large-format drawing of a man in Korean costume (see fig. 1), which is the principal subject of this book. The sheet shows a sailing vessel next to the figure (see fig. 4), a motif that evidences the long voyage of the unknown traveler, the continuous importance of Antwerp as a port of worldwide trade, and the ingenuity of the artist in directing the viewers' imagination to faraway lands.

At the end of the sixteenth century the direct water route to India was "knowne to the whole world," as the author of the address to the reader of the 1598 English translation of Jan Huygen van Linschoten's *Itinerario* boldly announced. While stressing that the English and the Dutch had by now taken the "Indian

Voyage" into their own hands, the author also acknowledges the Portuguese merchants for first discovering the "Indies" and distributing the land's "sundry commodities . . . not only to their owne Countrymen, but also to all Nations under Sunne."[6] The title illustration of the original edition of the Itinerario (fig. 39), published in Amsterdam in 1596, promoted the Dutch trading enterprise in India and promised detailed information about the Portuguese sea routes to the East. In the central oval a large fleet led by two Dutch warships is heading east with full-blown sails, as the sun breaks through the clouds. The ovals in the corners show views of the most important commercial cities linked to colonial trade: Antwerp, Amsterdam, Middelburg, and Linschoten's native Enkhuizen; in 1602, the latter three became headquarters of the VOC. Recommended as "commodious for all such as are desirous and curious lovers of Novelties," Linschoten's Itinerario includes a wealth of detailed information, especially on Goa, gathered from his own first-hand experience, other travelers and informants, and classical and more recent sources. It is to the Flemish imagery of such novelties that we now turn.

"Pratichi per il mondo": Antwerp's Knowledge of the World

Reprinted in several editions and translations throughout the late sixteenth and early seventeenth centuries, Guicciardini's Descrittione shaped Antwerp's identity and reputation for at least half a century. In the Descrittione, Antwerp is presented as a hub of world knowledge and world trade, a place that with its "great gathering of so many people and minds" and its "variety of diverse languages" contained the whole world. Guicciardini asserts that "without traveling, in one city, one can observe and follow the natures, customs, and manners of many nations . . . and because of these great crowds of foreigners there is always news of the whole world."[7] For Guicciardini, Antwerp's merchants distinguished themselves from others through their "experience in trading all over the world" and their great skills in "imitating foreigners with whom they easily enter into relationships."[8]

The "outstanding master craftsmen and artisans in all sorts of arts and trades" are likewise described by Guicciardini as masters of innovation and imitation, quick at accumulating new skills. Virtually all arts and trades were practiced in Antwerp. Many of these highly skilled craftsmen sold their works even

before they had actually completed them, and this buzzing cultural climate promoted achievement and success. Among the master artisans, Guicciardini singles out the goldsmiths; the glassmakers, who produce "very beautiful glasses in the Venetian manner"; the "cutters of jewels and other precious stones who create, in truth, marvelous works and carry on amazing commerce"; and the "various types of painters and sculptors" who, he states, outnumber all other craftsmen and artists.[9] Emphasizing the "ingenuity and cleverness" of these "great masters of arts and inventions," Guicciardini includes a whole section in the chapter on Antwerp on the "most noble and illustrious" artists of the Low Countries, starting his account with the story (as already transmitted by Vasari) of how Jan van Eyck "discovered oil paint" in about 1410.[10]

Guicciardini's account was used by the Flemish Jesuit Carolus Scribanius (1561–1629) for the chapter on Antwerp painters in his city encomium *Antverpia*, published together with *Origines Antverpiensium*, in 1610. As a representative of the interests and global ambitions of the Jesuit Society, Scribanius continued to advertise the city's wealth and financial trade, as well as the "copiousness of delicacies of all kinds" brought to Antwerp by the "multitude of ships" entering from foreign ports.[11] The whole range of the arts, including the mechanical arts, are given considerable attention, and painting is again set apart from the others since, as Scribanius proudly asserts, "more painters have been brought forth by this single republic in one century than from the entire world over many ages."[12] Scribanius further identifies the Jesuits as the primary force that transformed Antwerp into a model city of the (Christian) world. In the Jesuit propagation of the Catholic faith through their missionary work in Asia, the imagery and imaginings of faraway non-Christian lands played a crucial role. As Evonne Levy has suggested, the Jesuits fashioned themselves as religious professionals "living in (and dressing for) the world."[13] Rubens and his workshop produced painted and drawn portraits of the Jesuit father and missionary to China Nicolas Trigault, depicted in luxurious silk robes adopted from Chinese dress; these images promoted a religious identity embracing elements of the whole world (see figs. 21–23). The cult emerging around Francis Xavier as the "apostle of India and Japan" also gave the Jesuits ample opportunity to present themselves as the great colonizers of India, rivals and successors of the Portuguese merchant-explorers. Performed with

considerable pomp, the procession on the occasion of the canonization of Igna-
tius and Francis Xavier in Antwerp on July 24, 1622, as described at the time, was
led by representatives of the newly converted peoples of "India." Parading on rare
and exotic animals such as a "unicorn," a camel, and an elephant, they paid trib-
ute to the newly created saint.[14]

By the time Scribanius was writing his praise of the city, Antwerp had
regained and in many ways strengthened its position as one of the most impor-
tant markets for the production of and trade in luxury goods. While there was
a shift in the economy of Antwerp in the last quarter of the sixteenth century,
the marketing of luxury items such as silverwork, glassware, jewelry, and, above
all, paintings continued to flourish.[15] In the 1610s new subjects and iconographies
emerged in the visual arts that referenced the city as a "mother of artists" or a
"nurse of all arts."[16] Circulated in European centers of art and exported to over-
seas markets, these paintings advertised Antwerp as the site of a new collecting
culture that embraced old and new worlds and was informed both by intellectual
curiosity and commercial interests.

Also developed in the 1610s, the large market scenes by the Antwerp painter
Frans Snyders (1579–1657) equally appealed to the curiosity and imagination of
an expert viewer, as well as demonstrated the remarkable knowledge of the artist
about fruits, vegetables, and animals at a time when investigations into all kinds of
naturalia were thriving. Snyders's Vienna *Fish Market* (fig. 40), to which Anthony
van Dyck most probably contributed the figures, celebrates and fictionalizes what
may be called the "superabundance of not only ordinary, but also extraordinary"
products brought daily to Antwerp's markets, including its fish markets, which
were regularly mentioned as among the most notable sites in the town.[17] The vari-
ety of fishes, aquatic mammals, crustaceans, and mollusks (a large sturgeon, a
seal, and a sea otter are most prominent) also references the generative forces of
the world's many waters and seas. In the immediate foreground of the Vienna
painting, next to a basket with oysters, a variety of shells are presented as they
were at that time collected by artists, art lovers, merchants, explorers, and natural-
ists alike (fig. 41). These include a giant Triton shell, a polished Turbo shell, and
various Cowrie seashells, all found in warm Indo-Pacific waters, and which again
link Antwerp to the marvels and markets of the East.[18]

FIGURE 40 Frans Snyders (Flemish, 1579–1657) and Anthony van Dyck(?) (Flemish, 1599–1641), *Fish Market*, ca. 1621. Oil on canvas, 253 × 375 cm (99⅝ × 147⅝ in.). Vienna, Kunsthistorisches Museum, GG_383

FIGURE 41 Frans Snyders and Anthony van Dyck(?), *Fish Market* (detail, fig. 40), showing the collection of shells in the foreground

FIGURE 42 Maerten de Vos (Flemish, 1532–1603), the front facade of the Portuguese arch. Ink, gouache, and watercolor, 62.9 × 50.6 cm (24¾ × 19⅞ in.). From Johannes Bochius (Flemish, 1555–1609), *Descriptio publicae gratulationis . . . in adventu Serenissimi Principis Ernesti Archiducis Austriae* (Antwerp, ca. 1594/95). Bodleian Library, University of Oxford, MS. Douce 387, fol. 17r

That the Portuguese understood their trading ventures as the source of the great riches of the Spanish crown, which in 1580 had also gained control over Portugal, is further evident from the Portuguese contributions to Antwerp's performative culture. The triumphal arch erected—and likely also financed—by the Portuguese merchants on the occasion of the triumphal entry of Archduke Ernst into Antwerp in July 1594 was crowned by Neptune proudly holding up a "golden astronomical sphere" (fig. 42). Arranged on separate platforms on two elevations were the personifications of Mauritania on a lion, Brazil on an armadillo, Ethiopia on an elephant, and India on a rhinoceros—the colonies where the Portuguese kings had ruled and built their most lucrative trading posts.[19] Johannes Bochius (1555–1609), secretary of Antwerp's city council and author of the sumptuous festival book published by Plantin-Moretus the following year, points out in his commentary that the "growth of the Spanish power. . . had its origin with the kingdom of Portugal," which itself had dominion "over the entire coast of Mauritania, and everywhere in Africa itself."[20] The kingdom of Portugal also presented some extraordinary animals to the Christian world, which had not been seen in Europe since ancient times, as Bochius mentions; by that time, likenesses of these animals in various media had spread across Europe. The huge elephant set up as part of the decorations in the vicinity to the Oude Coren Markt (Old Grain Market) reminded its spectators of another elephant, again a gift of the king of Portugal, which had visited Antwerp in September 1563.[21]

"Indian" Objects in Antwerp Collections

Albrecht Dürer (1471–1528), who arrived in the city in the summer of 1520, was among the earliest artist-visitors drawn to Antwerp by the extraordinary novelty of foreign artifacts and natural objects available there. Even though he had earlier visited cosmopolitan Venice, Dürer wrote that he had not encountered these items before. In the diary relating his journey, Dürer diligently recorded all items that he acquired, exchanged for his artistic products, or received as gifts. Next to sugar delicacies and sweetmeats of all kinds, things listed as "Calicut" or "Indian" (coconuts, feathers, ivories, weapons, various kinds of cloth) in particular enthralled his imagination, conveying, as they did, knowledge of distant lands that aroused the senses. He was also presented with three parrots for which he acquired cages.[22] In

addition Dürer purchased drugs, dyes, pigments, and perfumes, and he revealed an avid interest in acquiring locally made cloth and imported exotic textiles (especially fine silks such as velvet, satin, and damask), as well as local and foreign clothing, including gloves, shoes, belts, bags, and, especially, headdresses, and hats.[23] That sixteenth-century men and women who cultivated their appearance looked toward Antwerp as the innovative center of sartorial arts is also confirmed by Guicciardini. In the *Descrittione* he asserts that in Antwerp "men and women of all ages dress very well . . . and always after the newest and finest fashions, but many much more richly and more pompously than civility and decency would allow."[24]

In the 1610s, perhaps the finest and costliest collection of headwear in Antwerp was owned by the Portuguese couple Isabella da Veiga (d. 1617) and Emmanuel Ximenes (1564–1632), knight of the Equestrian Order of Saint Stephen. Examples include a "black hat with a straw band on which are twenty-five little golden shells, and a black feather," and, kept among the jewels, a "black felt hat with violet feathers, and a golden pendant decorated with seventy-five rubies, six diamonds, and two pearls."[25] These were the kinds of hats and headgear that the three Magi and their entourage, quintessentially exotic figures, displayed in paintings of the period. For example, the turban of the black Magus in Rubens's *Adoration of the Magi* of 1609 (fig. 43), commissioned for the States Room of the Antwerp Town Hall, is adorned with a precious chain on which a pendant with a blue stone and a pearl is attached, as well as with bird of paradise feathers.[26] The luxuriant colors of its plumage, and the myths surrounding its existence, made this bird an emblem of the oriental East. Both Rubens's painting and the hats in the possession of Isabella da Veiga and Emmanuel Ximenes were objects of virtue and value that reflected the ingenuity and material resources invested in their design and creation.

Recent research into household inventories in seventeenth-century Antwerp has revealed that Portuguese merchant families in particular possessed objects associated with what was then called "India." Among these Portuguese merchants in Antwerp, Ximenes played a unique role, both in regard to the orientation of his collection and the types of activities in which he engaged. As a successful merchant, practitioner of alchemy (with a particular interest in the production of Venetian-style glass), discerning collector, and savant in various fields, Ximenes embodied this new kind of "useful" knowledge tied to the world of commerce,

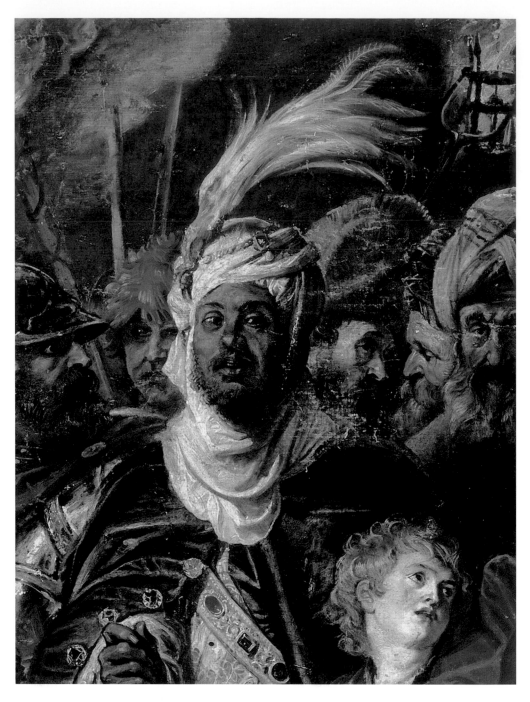

new fields of inquiry, and the (luxury) arts.[27] Ximenes not only possessed the largest collection of books in Antwerp at the time but also a remarkable number of optical and mathematical instruments (among them a telescope), several of which were produced by the Antwerp instrument maker Michiel Coignet (1549–1623).

The objects and artifacts displayed in the space that housed the mathematical and optical instruments, adjacent to the library, asserted Ximenes's Portuguese identity and origins through their links with international trade. The room contained a copper image of Mercury, the god of trade, commerce, and wealth, as well as three dried "Indian" animals: a crocodile, a salamander, and an "unknown" animal with scales (very likely an armadillo).[28] The walls of that room were decorated with various maps, among them a world map and a map of Africa. The latter was most probably the new map by Cornelis de Jode, issued in 1593, and it would have documented the Ximenes family's high commercial investments in African trade, including slave trade.[29] Conversely, the items labeled as "Indian" reflected the Ximenes family's involvement in financing the shipping route to India and their investments in Asian commodities.[30] As early as 1510, Paolo Cortesi, in his *De cardinalatu libri tres* (Three books on the Cardinalate), referred to the delight cardinals experienced looking at "paintings done from life which show the different characteristics of various [rare] creatures," and "a painted picture of the world or the depiction of its parts which have recently become known through the daring circumnavigation[s] accomplished by our people, such as the exploration[s] of Manuel, King of the Portuguese, around India."[31]

Sites of Encounters

Ximenes's interest in the Portuguese world of commerce and knowledge, which he helped shape, is also reflected in his book holdings. Ximenes possessed not only a copy of the Latin edition of Linschoten's *Itinerario* (The Hague, 1599), but also a series of other books referring to voyages and explorations. Included among them were narratives surrounding specific voyages, like those of Thomas Cavendish, Francis Drake, and John Hawkins to West India; Pedro de Cieza de León to Peru; the travels of Pedro Teixeira in Persia; and Cornelis de Houtman's trip to the East Indies.[32] These were complemented with several newer instructional tracts on navigation, such as the *Spieghel der Zeevaert* (Mirror of navigation)

and *Thresoor der Zeevaert* (Treasure of navigation) by the Enkhuizen pilot and cartographer Lucas Janszoon Waghenaer, both of which included excellent sea charts;[33] and the 1612 edition of Robert Hues's treatise on the use of globes. Finally, the library contained several world and regional atlases as well as a bound edition of star charts. All of these volumes, coupled with the presence in the palace of maps, globes, a telescope, and other mathematical instruments, indicate a strong and active interest in long-distance travel and the technical aspects of its planning and execution.

Given the crucial importance of the maritime world for Ximenes, it is furthermore not surprising that the wealthy merchant also owned Rubens's first maritime allegory, a *Birth of Venus* of about 1615 (formerly in Potsdam, Bildergalerie Sanssouci). In Rubens's painting two Nereids (sea nymphs fathered by the Greek sea-god Nereus) proffer their gifts: shells, corals, and oriental pearls—the very goods Ximenes traded and collected. The composition was engraved by Pieter Soutman (fig. 44), who in addition to making other changes replaced the rudder, held by the elderly man crowned with a remarkable wreath of reeds and mallows, with a trident, thus transforming Oceanus (the ruler of oceans) into the sea-god Neptune.[34] Eminently suited for the palace of a Portuguese merchant whose wealth came from seaborne trade, Rubens's *Birth of Venus* also pays homage to the Greek painter Apelles's most celebrated painting, an *Aphrodite Anadyomene*, or a Venus emerging from the sea. It would have offered its owner a whole series of artifices from which to take visual pleasure: from the flesh tints, changing between male and female; to the shimmering surface of the water; to the luster of pearls and seashells.

Images of *constkamers*, the pictorial genre developed in Antwerp in the 1610s, related to and interpreted the long history of Antwerp as a city of the world. The depicted "chambers of art" often include tables on which riches from faraway lands and luxury items produced by Antwerp's artists and artisans are displayed next to each other. For example, a *constkamer* ascribed to Hieronymus Francken II (1578–1623) and Jan Brueghel the Elder (1568–1625) (figs. 45, 46) shows, on the table in the foreground, a heavenly globe most probably by the Flemish cartographer Jodocus Hondius; various maps and books of sea charts; a collection of shells, corals, and precious stones; two birds of paradise; and several pieces of jewelry. The

FIGURE 44 Pieter Claesz. Soutman (Dutch, ca. 1580–
1657) after Peter Paul Rubens, *The Birth of
Venus*, ca. 1620/22. Etching and engraving,
39.8 × 48.5 cm (15 11/16 × 19 1/8 in.). Antwerp,
Koninklijk Museum voor Schone Kunsten,
10614

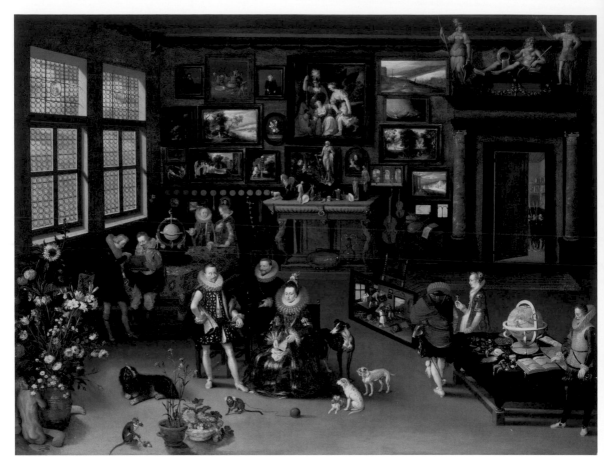

FIGURE 45 Hieronymus Francken II (Flemish, 1578–1623) and Jan Brueghel the Elder (Flemish, 1568–1625), *The Archdukes Albert and Isabella Visiting a Collector's Cabinet*, ca. 1621–23. Oil on panel, 94 × 123.3 cm (37 × 48⁹⁄₁₆ in.). Baltimore, Walters Art Museum 37.2010

FIGURE 46 Hieronymus Francken II and Jan Brueghel the Elder, *The Archdukes Albert and Isabella Visiting a Collector's Cabinet* (detail, fig. 45), showing the items on the table in the right foreground

arrangement thus visually links the most marvelous creations of art and nature as well as local geographical knowledge, mercantile skills, and virtuoso craftsmanship and invention.[35] The Baltimore *constkamer*, which features Rubens's patrons, the Archduke Albert and the Archduchess Isabella, as princely visitors, shows how chambers of art functioned as sites where *liefhebbers van consten* (lovers of the arts) conversed about the material and natural world, meditating upon what Guicciardini, Scribanius, and others called the "ingenuity" of Antwerp's men of learning, art, science, and commerce.

In this essay I have outlined the ways in which the Portuguese trading ventures overseas had transformed Antwerp into a "warehouse," "entrepôt," and "market" of the world where exotic commodities and products of many different arts and crafts were traded, exchanged, collected, and offered for view. Contemporary city descriptions list among Antwerp's most notable sites the port, the stock exchange, trading houses of the foreign merchants, various *panden* or specialty markets, and Plantin's publishing firm, thus the very sites where commodities and information were circulated and exchanged. It was within such encounters and exchanges of knowledge, ideas, and objects between merchants, craftsmen, and artists that new types of artworks were created in Antwerp, works that resonated with various cultural and geographical spaces and continued the image of the city as world entrepôt. The paintings and prints discussed in this essay, while linked to the spheres of consumption and commerce, also display Rubens's and his fellow Antwerp artists' deep investment in the world of knowledge achieved through observation and the senses. Their willingness to collaborate with each other and to engage with other lovers of art and learned men prompted them to create a kind of painterly allure that still holds our curiosity and attention today.

NOTES

1 Lodovico Guiccardini, *The Description of the Low Countreys and of the Provinces Thereof*, translated and abridged by Thomas Danett (London, 1593), fol. 27. For Guicciardini, see Aristodemo Dina, "Lodovico Guicciardini," *Dizionario Biografico degli Italiani* 61 (2003), pp. 121–27. For the impact of the Portuguese enterprise on the European spice markets, see Donald F. Lach, *Asia in the Making of Europe*, vol. 1, *The Century of Discovery*, bk. 1 (Chicago and London, 1965), pp. 92–114; Harold J. Cook, *Matters of Exchange: Commerce, Medicine, and Science in the Dutch Golden Age* (New Haven and London, 2007), p. 11; and Sanjay Subrahmanyam, "Als die Welt Portugal entdeckte: Zehn Jahre portugiesisch-asiatischer

Begegnung, 1498–1508," in *Novos Mundos—Neue Welten: Portugal und das Zeitalter der Entdeckungen*, exh. cat. (Berlin, Deutsches Museum), edited by Michael Kraus and Hans Ottomeyer (Dresden, 2007), pp. 25–45.

2 On the notion of world cities as sites of global exchange and the production of (local) knowledge, see Antonello Romano and Stéphane van Damme, "Science and World Cities: Thinking Urban Knowledge and Science at Large (16th–18th Century)," *Itinerario* 23 (2009), pp. 79–95.

3 Guido Marnef, *Antwerp in the Age of Reformation: Underground Protestantism in a Commercial Metropolis, 1550–1577*, translated by J. C. Grayson (Baltimore and London, 1996), p. 3. For the original citation see Guido Marnef, *Antwerpen in de tijd van de Reformatie: Ondergronds protestantisme in een handelsmetropol 1550–1577* (Antwerp and Amsterdam, 1996), p. 23.

4 See Cook, *Matters of Exchange* (note 1), pp. 13–20; *Virtue: Virtuoso, Virtuosity in Netherlandish Art*, edited by Jan de Jong et al., *Netherlands Yearbook for History of Art* 54 (2003), esp. the introduction by Joanna Woodall ("In Pursuit of Virtue"), pp. 7–24.

5 Cornelius Kilianus, *Teutonicae Linguae Dictionarium* (Antwerp, 1599), p. 522, defines "stapel" as a "public place where by royal privilege vines, skins and leather, grain, woolen fabrics, and exotic commodities (*merces exoticae*) are brought together to be traded or sold." *Stapelhuys* and *schuyre* are both translated as *horreum* (storehouse) in Kilianus, Teutonicae Linguae Dictionarium, pp. 476, 522. See also Lissa Roberts, "Centres and Cycles of Accumulation," in *Centres and Cycles of Accumulation in and Around the Netherlands during the Early Modern Period*, edited by Lissa Roberts, Low Countries Studies on the Circulation of Natural Knowledge 2 (Vienna, 2011), pp. 3–27.

6 Iohn Huighen van Linschoten, *His Discours of Voyages into ye Easte & West* (London, 1598), fols. A2v–A4r.

7 For the following, I have been using mostly the third Italian edition, published by Christopher Plantin and updated by the author until 1587: Lodovico Guicciardini, *Descrittione di tutti i Paesi Bassi* (Antwerp, 1588), p. 158; and the revised and expanded Dutch edition: Lodovico Guicciardini, *Beschryvinghe van alle de Nederlanden*, translated by Cornelius Kilianus, augmented by Petrus Montanus (Amsterdam, 1612), p. 93.

8 See Guicciardini, *Descrittione* (note 7), p. 155: "Sono persone humane, civili, ingegnosi, pronti ad imitare il forestiero, & facili a far' seco parentado. Sono pratichi per il mondo." See also Guicciardini, *Beschryvinghe* (note 7), p. 92.

9 See Guicciardini, *Descrittione* (note 7), p. 156; and Guicciardini, *Beschryvinghe* (note 7), p. 92.

10 See Guicciardini, *Descrittione* (note 7) pp. 127–32, at 127: "Pittori, che in tutte le attioni rendono conto & chiara testimonianza dell'acutezza, & dell'ingegno loro." See also Guicciardini, *Beschryvinghe* (note 7), pp. 79–82.

11 See Carolus Scribanius, *Antverpia* (Antwerp, 1610), p. 33. See also Raingard Esser, *The Politics of Memory: The Writing of Partition in the Seventeenth-Century Low Countries* (Leiden, 2012), pp. 168–82.

12 See Scribanius, *Antverpia* (note 11), pp. 31–43. On the chapter "On the Art of Painting" in *Antverpia*, see Julius S. Held, "Carolus Scribanius's Observations on Art in Antwerp," *Journal of the Warburg and Courtauld Institutes* 59 (1966), pp. 174–204.

13 Evonne Levy, "Jesuit Identity, Identifiable Jesuits? Jesuit Dress in Theory and in Image," in *Le monde est une peinture: Jesuitische Identität und die Rolle der Bilder*, edited by Elisabeth Oy-Marra and Volker R. Remmert, with the collaboration of Kristina Müller-Bongard (Berlin, 2011), pp. 127–52, at 143.

14 Karel Porteman, "Exotisme en spektakel: De Antwerpse jezuïtenfeesten van juli 1622," in *Vreemden vertoond: Opstellen over exotisme en spektakelcultuur in de Spaanse Nederlanden en de Nieuwe Wereld*, edited by Johan Verberckmoes (Leuven, Belg., 2002), pp. 103–19.

15 This shift of focus in the economy has been described as one from global to overland commerce and financial affairs. It is now generally assumed that this economic reorientation was part of a larger development and not primarily

caused by the closing of the river Scheldt by the Dutch after the recapture of Antwerp by the Spanish troops in 1585. See Catharina Lis and Hugo Soly, "Export Industries, Craft Guilds and Capitalist Trajectories, 13th to 18th Centuries," in *Craft Guilds in the Early Modern Low Countries: Work, Power, and Representation*, edited by Maarten Prak et al. (Aldershot, Brit., 2006), pp. 107–32, esp. 126–28; Clé Lesger, *The Rise of the Amsterdam Market and Information Exchange: Merchants, Commercial Expansion and Change in the Spatial Economy of the Low Countries, c. 1550–1630* (Aldershot, Brit., 2006), pp. 3–13.

16 Karel van Mander, *The Lives of the Illustrious Netherlandish and German Painters, from the First Edition of the Schilder-boeck (1603–1604)*, edited by Hessel Miedema, vol. 1 (Dornspijk, Neth., 1994–99), p. 134 (fol. 219r).

17 See Guicciardini, *Beschryvinghe* (note 7), p. 69. For Snyders's *Fish Markets*, see Susan Koslow, *Frans Snyders: The Noble Estate: Seventeenth-Century Still-Life and Animal Painting in the Southern Netherlands* (Brussels, 2006), pp. 137–49.

18 For the wide range of meanings and uses of shells, see Karin Leonhard, "Shell Collecting: On 17th-Century Conchology, Curiosity Cabinets and Still Life Painting," in *Early Modern Zoology: The Construction of Animals in Science, Literature and the Visual Arts*, edited by Karl A.E. Enenkel and Paul J. Smith, Intersections 7 (Leiden, 2007), pp. 178–214.

19 See Johannes Bochius, *Descriptio publicae gratulationis, Spectaculorum, et Ludorum, in adventu Serenissimi Principis Ernesti Archiducis Austriae...* (Antwerp, ca. 1594/95); and Ann Diels, "Van opdracht tot veiling: Kunstaanbestedingen naar aanleiding van de Blijde Intrede van aartshertog Ernest van Oostenrijk te Antwerpen in 1594," *De zeventiende eeuw* 19 (2003), pp. 25–54. For an English translation of the "description of the triumphal arch of the Portuguese" in Johannes Bochius's festival book, see *Europa Triumphans: Court and Civic Festivals in Early Modern Europe*, edited by J.R. Mulryne et al., vol. 1 (Aldershot, Brit., 2004), pp. 492–576.

20 See Bochius, *Europa Triumphans* (note 19), pp. 520–21.

21 *Prints and the Pursuit of Knowledge in Early Modern Europe*, exh. cat., Harvard Art Museums, Cambridge, Massachusetts, edited by Susan Dackerman (New Haven and London, 2011), pp. 160–61. For a discussion of exotic animals at the courts of Iberia, see Almudena Pérez de Tudela and Annemarie Jordan Gschwend, "Renaissance Menageries: Exotic Animals and Pets at the Habsburg Courts in Iberia and Central Europe," in *Early Modern Zoology* (note 18), pp. 419–47.

22 For a discussion of these items mentioned in Dürer's diary, see Jean Michel Massing, "The Quest for the Exotic: Albrecht Dürer in the Netherlands," in *Circa 1492: Art in the Age of Exploration*, exh. cat., edited by Jay A. Levenson (Washington, 1991), pp. 115–19. See also Jeffrey Chipps Smith, "The 2010 Josephine Waters Bennett Lecture: Albrecht Dürer as Collector," *Renaissance Quarterly* 64 (2011), pp. 1–49. "Indian" was a broad and ambiguous term that could in fact indicate origins in either the Far East or the Americas. See Jessica Keating and Lia Markey, "'Indian' Objects in Medici and Austrian-Habsburg Inventories: A Case-study of the Sixteenth-Century Term," *Journal of the History of Collections* 23 (2011), pp. 283–300. "Calicut" was often interchangeably used with "Indian."

23 For Antwerp as a center of fashion and design, see Ulinka Rublack, *Dressing Up: Cultural Identity in Renaissance Europe* (Oxford, 2010), pp. 182–87.

24 See Guicciardini, *Descrittione* (note 7), p. 92.

25 Erik Duverger, "Inventaris van de nagelaten goederen van Vrouw Isabella da Vega, echtgenote van Emmanuel Ximenez, Ridder van de Orde van de Heilige Stefanus van de Portugese Natie," June 13–28, 1617, in *Antwerpse kunstinventarissen uit de zeventiende eeuw*, vol. 1 (Brussels, 1984), pp. 419, 431.

26 For the black Magus's turban, see Alejandro Vergara, "The Adoration of the Magi: A Case Study in Rubens' Creativity," in Alejandro Vergara, *Rubens: The Adoration of the Magi* (London, 2005), pp. 55–123.

27 The collection of Emmanuel Ximenes and Isabella da Veiga is the topic of a collaborative book project by Sven Dupré and Christine Göttler. For the central importance of luxury glass in Antwerp's knowledge culture, see Sven Dupré, "Trading Luxury Glass, Picturing Collections and Consuming Objects of Knowledge in Early Seventeenth-Century Antwerp," in *Silent Messengers: The Circulation of Material Objects of Knowledge in the Early Modern Low Countries*, edited by Sven Dupré and Christoph Lüthy (Berlin, 2011), pp. 261–92.

28 Other objects labeled "Indian," both in this room and others throughout the Ximenes palace, include carpets, a bedstead, several coconut shells, and a leather bag. (For use of the term "Indian," see note 22.)

29 Richard L. Betz, *The Mapping of Africa: A Cartobibliography of Printed Maps of the African Continent to 1700*, Utrechtse historisch-cartografische studies 7 ('t Goy Houten, Neth., 2007), pp. 31–35 ("The Portuguese in Africa") and 154–55 (on De Jode's 1593 *Africae Vera Forma*). See also Filipa Ribeiro da Silva, "Crossing Empires: Portuguese, Sephardic, and Dutch Business Networks in the Atlantic Slave Trade, 1580–1674," *The Americas* 68 (2011), pp. 7–32, esp. 7–21.

30 James C. Boyajian, *Portuguese Trade in Asia under the Habsburgs, 1580–1640* (Baltimore and London, 1993), pp. 116–17.

31 Kathleen Weil-Garris and John F. D'Amico, "The Renaissance Cardinal's Ideal Palace: A Chapter from Cortesi's 'De Cardinalatu,'" *Memoirs of the American Academy in Rome* 35 (1980), pp. 45–123, at 95-97.

32 See *Last Voyages: Cavendish, Judson, Ralegh: The Original Narratives*, edited by Peter Edwards (Oxford, 1988); Pedro de Cieza de León, *The Discovery and Conquest of Peru: Chronicles of the New World Encounter*, edited and translated by Alexandra Parma Cook (Durham, 1988); *The Travels of Pedro Teixeira: With His 'Kings of Harmuz' and Extracts from His 'Kings of Persia,'* translated and annotated by William F. Sinclair and Donald Ferguson (London, 1902; reprint, Aldershot, Brit., 2010); Willem Lodewijcksz, *Om de Zuid: De eerste schipvaart naar Oost-Indië onder Cornelis de Houtman, 1595–1597*, edited by Vibeke Roeper and Diederick Wildeman (Nijmegen, Neth., 1997); and M. Beekman, *Troubled Pleasures: Dutch Colonial Literature from the East Indies, 1600–1950* (Oxford, 1996), pp. 17–116.

33 Cornelis Koeman, *The History of Lucas Janszoon Waghenaer and His 'Spieghel der Zeevaert'* (Lausanne, Switz., 1964).

34 See Elizabeth McGrath, "The Streams of Oceanus: Rubens, Homer and the Boundary of the Ancient World," in *Ars naturam adiuvans: Festschrift für Matthias Winner zum 11. März 1996*, edited by Victoria von Flemming and Sebastian Schütze (Mainz am Rhein, Ger., 1996), pp. 464–76. The painting, formerly in Potsdam, has been lost since World War II. On Soutman's print, see *Copyright Rubens: Rubens en de Grafiek*, exh. cat., Koninklijk Museum voor Schone Kunsten Antwerpen, edited by Nico van Hout (Ghent, Belg., 2004), pp. 143–44.

35 Victor I. Stoichita, *The Self-Aware Image: An Insight into Early-Modern Meta-Painting* (Cambridge, 1997), pp. 123–27. There is a rich literature on Antwerp depictions of *constkamers*. Recent studies include Elizabeth Alice Honig, *Painting and the Market in Early Modern Antwerp* (New Haven, 1998), pp. 177–89; and Alexander Marr, "The Flemish 'Pictures of Collections' Genre: An Overview," *Intellectual History Review* 20 (2010), pp. 5–25.

About the Contributors

Christine Göttler is a professor of art history at the University of Bern. Her main research interests concern the intersections of art, religion, and the sciences in early modern Europe, particularly the Netherlands. Her most recent book is *Last Things: Art and the Religious Imagination in the Age of Reform* (2010). She is also editor (with Wietse de Boer) of *Religion and the Senses in Early Modern Europe* (2012).

Burglind Jungmann is a professor of Korean art history at the University of California, Los Angeles. Her research interests include the history of Korean painting in its cultural, social, and political context and the exchange in art between China, Korea, and Japan. Her book *Painters as Envoys: Korean Inspiration in Eighteenth Century Nanga* (2004) explores the impact of Korean embassies to Japan on Japanese literati painting. She is also coeditor (with Adele Schlombs and Melanie Trede) of *Shifting Paradigms in East Asian Visual Culture: A Festschrift for Lothar Ledderose* (2012).

Kim Young-Jae is a senior curator in the Department of Collections Management at the National Folk Museum of Korea. She received her doctorate in history at the National Taiwan Normal University. Her current research focuses on traditional Korean costume and culture, and she produces traditional Korean costumes based on historical documents and excavated artifacts.

Stephanie Schrader is an associate curator in the Department of Drawings at the J. Paul Getty Museum, specializing in sixteenth–eighteenth-century Dutch and Flemish art. Her recent publications include "Naturalism Under the Microscope: A Technical Study of Maria Sibylla Merian's *Metamorphosis of the Insects of Surinam*," *Getty Research Journal*, no. 4 (2012), and two contributions to the Metropolitan Museum of Art's exhibition catalogue *Man, Myth, and Sensual Pleasures: Jan Gossart's Renaissance* (2010).

Index

Manchu invasions, 25, 70, 72

Ming dynasty, 4, 10, 40

portraiture, 74–75, 78, 80

Qing dynasty, 72, 74–75, 84

Christianity

Adoration of the Magi and global reach of, 3

Eastern views of Jesus, 73

Japanese converts, 52, 64n50, 92

Korean converts, 86n13

in Korean texts, first mention of, 67

paganism vs., 40, 56, 60–61, 65n63

slaves forcibly converted to, 12, 13

See also Jesuits

Cieza de León, Pedro de, 99

clothing

Antwerp as fashion center, 97

banggeon (headdress), 4, 27, 27, 52

cheollik (coat), 4, 32, 34, 36, 37, 37n3, 52, 64n47

dapho (overcoat), 29, 32, 33, 34, 37n3

ip (hat), 32, 35

Jesuit appropriation of Chinese costume, 14, 39–46, 48–52, 62n9, 63n40, 64n45, 92

Joseon collars and sleeves, 27–30

Joseon headgear, 4, 25–27, 52, 54, 82

Joseon male apparel, summarized, 32, 35

manggeon (headband), 26–27, 26

mokwha (boots), 32, 35

paganism and exotic costume, 60–61

Rubens's general approach to exotic costume, 1, 3–4, 53–54

of Siamese ambassadors, 16

social rank and, 10, 25, 37, 44, 97

Western knowledge of Korean dress, 4, 7, 9, 39, 54, 61

Coignet, Michiel, 99

collection of precious objects

Antwerp as center for, 90, 93, 96–97, 99–100, 104, 105n5, 107n28

East Asian views on, 84

English art collectors, 14, 16–17, 22n46, 22n51

European "imaginary collections," 87n27

Jesuit cache of East Asian items, 50, 52–53

Jesuit gifts to Korean elite, 72

Korean study screens and, 67, 75, 82, 84, 87n26

Swedish collector Tessin, 62n15

Complete Map . . . of the World (eight-panel screen), 70, 70–71, 73–74, 74–75, 85n9

Complete Map of the World (Ricci), 70, 73, 85n9

Confucianism

on hair cutting, 64n57

Jesuits as *literati*, 39–40, 44, 48, 50–51, 62n9, 63n40

on Jesus, 73

portraiture and, 74–75, 80

Silhak movement, 72, 78, 85n6

Yi Su-gwang and, 86n13

constkamer depictions, 100, 104

Cook, Harold J., 90

Corea, Antonio, 11, 12–13, 20n1

Cortesi, Paolo, 99

costume. *See* clothing

Dankook University Museum, 64n47

dapho (overcoat), 29, 32, 33, 34, 37, 37n3

de Bry, Johann Theodor. *See* Bry, Johann Theodor de

De cardinalatu libri tres (Cortesi), 99

De Christiana Expeditione apud Sinas (Ricci), 46, 47, 48, 54

De Vita Francisci Xaverii (Tursellinus), 56, 65n63